Pigcasso

Pigcasso

The Painting Pig that
Saved a Sanctuary

JOANNE LEFSON

First published in Great Britain in 2023 by Cassell, an imprint of
Octopus Publishing Group Ltd
Carmelite House
50 Victoria Embankment
London EC4Y 0DZ
www.octopusbooks.co.uk

An Hachette UK Company
www.hachette.co.uk

Distributed in the US by
Hachette Book Group
1290 Avenue of the Americas
4th and 5th Floors
New York, NY 10104

Distributed in Canada by
Canadian Manda Group
664 Annette St.
Toronto, Ontario, Canada M6S 2C8

ISBN 978-1-78840-420-4

A CIP catalogue record for this book is available from the British Library.

Printed and bound in Great Britain

10 9 8 7 6 5 4 3 2 1

Publisher: Trevor Davies
Senior Editor: Alex Stetter
Design Director: Mel Four
Production Manager: Caroline Alberti

Illustrations by Suzi Kemp
All photographs courtesy of the author

p28: 'Some Days Are Diamonds (Some Days Are Stone)', lyrics by Dick Feller
p145: 'On the Wings of a Dream', lyrics by John Denver

This FSC® label means that materials used

for the product have been responsibly sourced

MIX
Paper | Supporting
responsible forestry
FSC® C104740

To Oscar, my inspiration.

Pigcasso, my equal.

And to the billions of invisible farmed
animals who live and die in darkness:

These pages are for you.

Art does not reproduce the visible;
rather it makes visible.

Paul Klee

Contents

Foreword
by Dame Jane Goodall

I was born with a love of, and fascination for, all animals. I think my love of pigs began when I was eight years old and read *The Story of Doctor Dolittle*. In that book I was introduced to Gub-Gub the pig, an absolutely enchanting character. My first experience of habituating any animal just happened to be a pig. I met him when I was about ten, during a two-week holiday in the country with my mother and sister. I named him Grunter and he lived in a field with about nine other pigs, all Saddlebacks. I wanted to get closer, but they ran off when I climbed over the gate.

But I was determined, and every day I took my lunchtime apple to eat in the field and throw the core towards the pigs. Each day I went a little closer, and finally one of them – Grunter – lost his fear and let me approach. When he

finally plucked up courage and took the offering from my hand, I was so very excited. And one day he let me rub his back. It was a moment I never forgot. I'm glad I had no idea, back then, that Grunter was destined to be slaughtered for food; it would have broken my heart.

In 1960, 16 years after meeting Grunter, I began my observation of the wild chimpanzees in Gombe Stream National Park in Tanzania. It was about four months before they began to lose their fear of me and I was able to know the different individuals: David Greybeard, who showed me that chimps could use and make tools, and old Flo, who taught me about motherhood, and all the rest.

After I'd been at Gombe for a year, I went to Cambridge University. I'd not gone to college when I left school (we couldn't afford it), so I knew nothing about the reductionist way in which the scientific community thought about animals. I was horrified when I was criticized by the professors for naming my subjects instead of giving them numbers, and for talking about their different personalities, minds capable of solving problems and emotions similar to those we call happiness, sadness, anger, grief and so on. Those, I was told, were unique to humans. Luckily I'd had

a wonderful teacher as a child, who had taught me that in this respect the professors were wrong: my dog Rusty. Anyone who has shared their life in a meaningful way with a dog, cat, horse, bird (or pig!) knows that we are not the only beings with personalities, minds and emotions.

Gradually, as my catalogue of detailed observations grew, substantiated by the film material shot by my then-husband Hugo van Lawick, scientists began to drop that way of thinking about other animals, and today it is widely recognized that mammals, birds, reptiles, amphibians and other animals are sentient. I'm sure many of you reading this have watched the Oscar-winning film *My Octopus Teacher* on Netflix. If not, I recommend you do so.

When I give lectures around the world, I take with me a collection of toys to act as props and sit them in a row on a table by the podium. I use Cow (hardly an imaginative name!) to illustrate to children how food goes in one end and gas comes out the other (which gets a giggle), explaining this is the greenhouse gas methane. I also talk about the horrendous way dairy cows are treated, bred for ever-larger udders. Cows are artificially inseminated. When the baby is born, the mother is allowed to lick her

child to get her milk flowing and then, after all she has gone through and as she starts to bond with her little one, the calf is dragged away. The anguished way they call to each other is heart-breaking. And we drink the milk intended for the calf.

I use Ratty (named for the water rat in *The Wind in the Willows*) and Octavia the Octopus to talk about the extraordinary intelligence of both species. And Piglet (the name comes, of course, from *Winnie-the-Pooh*) helps me explain that pigs are as smart as dogs, that each one has his or her own personality.

There has been much written on the intelligence of pigs, ranging from articles in scientific journals to books about pigs who have been adopted as pets. I once met LiLou, a therapy pig. She is taken, regularly, by the couple who raised her, to San Francisco Airport. And I saw for myself how the sight of her causes stressed passengers to smile and relax, and tired, fretful children to light up with pleasure. She even plays a toy piano!

And then someone told me about an amazing pig who had been rescued on her way to slaughter by Joanne Lefson. I watched a video of this animal at work on one of her

canvases and understood why she had been named after the famous artist Picasso, with a delightful play on words. As I watched the joy with which she painted I was moved to tears, to think she might have been killed to become pork chops and bacon. I at once wrote to Joanne and am now the proud owner of an original Pigcasso artwork.

I almost always talk about this wonderful pig in my lectures, and show a short video of her at work. And so many people tell me, afterwards, that they can never eat pork or bacon or sausages again. You cannot watch her without being impressed by the obvious satisfaction she derives from executing a painting. Joanne tells me how Pigcasso inspires and impresses all those who meet her. She is a true ambassador for her species, for all those factory-farmed pigs who are forced to lie on bare floors and never know the joy of rootling in the ground, wallowing in the mud, breathing fresh air.

For just as Pigcasso has her own special personality, so too do all those others: billions of intelligent individuals incarcerated in the living hell of animal concentration camps, and treated as living pork and bacon and sausages. It is my hope that if you eat meat, this book will help you

to understand the secret suffering of the animals whose life was taken to put the food on your plate. That you will refuse to buy meat from intensively farmed animals and pay a little more for free-range produce. And, perhaps, you will be inspired to move towards a healthy, plant-based diet. Let us work together to create a better world for the animals with whom we share the planet.

Dame Jane Goodall, primatologist
and United Nations Messenger of Peace, 2021

Preface

Before we begin . . .

There are two things we need to know before heading down the farm road. Firstly, sport, and golf in particular, has played a big part in my journey, even though these days my clubs gather more dust than grass. So if you come across the occasional birdie, hole-in-one or other obscure sporting term, I hope you'll forgive me. I'm not trying to be clever or cryptic, it's just deeply ingrained in my DNA. A quick Google search will sort out any confusion. Secondly, I am the sort of person who is likely to break the ice at a dinner party with something like, 'What's the difference between a hippo and a Zippo? One is really heavy and the other is a little lighter.' I have always enjoyed a good pun. I like the good ones and the bad ones, and

the ones in between. From 'Time flies like an arrow, fruit flies like a banana' all the way to the idea that becoming a vegetarian might just be a massive missed steak, I can't help myself. Never have, never will. They make me smile. If I'd had my way, this book would be a few thousand words longer to accommodate as many puns as I could get away with, but the editors won. Sad face. Even so, you'll see more plays on words in the pages that follow than Shakespeare ever dreamed of, and as with the shanks and duffs mentioned above, I do hope you'll take them in your stride. Who knows, you may even grow to enjoy them when you realize that if one goes seven days without a pun, it'll make one week.

1.
Pigtails & Pork

It was viciously hot. A gang of seagulls squabbled over French fries squashed on the cobblestones, and a subtle blend of seaweed and marine fuel hung heavy in the foreshore air. None of which mattered to the assembled guests, whose eyes were fixed on the customized chauffeur-driven vehicle that had just pulled up on the quayside. The doors were flung open to a collective gasp as the young artist stumbled out, brimming with self-confidence, oblivious to the applause and naked as the day she was born.

She charged down the red carpet, barged her way through the guests, collided with the champagne table, knocked over the ice box and sent VIPs scrambling for cover for fear of having their Pradas flattened or their Guccis gouged. Complete and utter chaos. But it wasn't our first rodeo, and I'd made sure she had a minder on hand to put an arm around her shoulder and calm her down enough to get the formalities under way.

I tried to make a speech but the South Easter was howling, as it often does in the harbour, and the wind blew the words away. Worst of all, I had brought a van-load of friends who absolutely loved the show and got totally into it. And then we all went for dinner and everyone ordered pork belly, which was mildly inappropriate, considering that the star of the show was a 300kg pig.

When Pigcasso's OINK! exhibition opened in 2018 at the Victoria & Albert Waterfront in Cape Town, South Africa, it was the first time in history that art painted by an animal went on show in a solo exhibition. I'd been toying with the idea of a pop-up gallery for ages and already had a connection at the Waterfront through some work we'd done with Oscars Arc, the non-profit organization I'd set up to

inspire people to adopt dogs. My inside man gave us the thumbs up without me needing to twist his arm – and just like that, Pigcasso's work was showcased in a bright pink shipping container set up for all to see near the swing bridge that carries visitors to the Robben Island ferry.

In the three months that it ran, the show totally overachieved. It was a roaring success in every possible way, including a rush of sales, both locally and abroad. But what mattered most was that the intrigue and interest centred equally around the art and the artist. It wasn't just a champagne moment; it was an undeniable turning point.

We were the headline act at a destination that claims to be one of Africa's biggest tourist attractions, pulling in more than 20 million visitors a year, so it was no surprise the international press went wild. Even German public powerhouse TV broadcaster ZDF picked it up, together with *Der Spiegel*, the largest weekly magazine in Europe. These were serious media channels with an audience of millions. The incoming emails nearly crashed our server and the phone rang off the hook.

If you had told me before this all started – that I would move to the Western Cape winelands of South Africa

when I don't like wine, build a monstrous barn and end up being personal assistant, creativity mentor and curator to a 300kg-plus painting pig – I would have squealed, 'WTF!' But Pigcasso's journey from slaughterhouse to sanctuary is extraordinary, rather than surprising.

Long before she became the world's biggest artist, I had developed a great love for animals, including pigs. Pork chops, pork belly, pancetta, leg of lamb, Boston butt, you name it: meat protein and I hit it off from the very beginning. There wasn't a school lunch box without a cold cut, nor a breakfast without bacon bits. I sat, I ate, and life was good: I did exactly as my parents had done. We all loved animals, and we all ate them without a second thought.

And when I say we all loved animals, it wasn't just in theory. Growing up, my best friend was always a dog adopted from the local shelter. I was a member of every animal rights group on the planet, I spent every weekend minute volunteering or raising money for the local dog shelter, and my dream was to join Greenpeace and patrol the seven seas on *Rainbow Warrior*. And yet somehow I'd never realized I was having lunch on the hoof. I loved pigs,

but still served them up and ate them. End of story. Then one day, it all changed.

High school in the late 1980s was not an easy place. I went to a very conservative all-girls institution in the shadow of Cape Town's famous Table Mountain, where we wore ties, thick black stockings an inch above the knee and heavy, formal blazers. If it wasn't for the skirts and pigtails, you'd be forgiven for thinking we were boys. Movies like *Dirty Dancing* were banned, the Lord's Prayer was sung in the hall every morning, and if you stepped out of line, best you watch *The Shawshank Redemption* and pick up some tips on how to survive solitary. Lunch break was signalled by a loud siren and was probably the reason I'd never dropped out of high school. It was the highlight of my day.

The tuck shop was everything you'd expect from a crazy-strict, self-contradictory establishment. There were no green beans, roast carrots or Brussels sprouts that had to be consumed before getting your scoop of ice cream. Rather, it was my hog heaven. Chips, Cokes, chocolates, and the absolute best: the ham and cheese sandwich. I'd grab my grub, find an inviting spot on the rolling grass and sit and chat with a group of friends.

We'd poke fun at the teachers, talk about boys and discuss in detail how to 'use tongue' on that first kiss, whenever that moment would arrive. (Not that the crew-cut tomboy in me was particularly interested in such topics. When I wasn't pulling the nylon hair from every Barbie within arm's reach, my spare time was mostly taken up by exercise, thanks to an athletic father and a golf-obsessed family.)

On one particular day, much like any other, it was just my friend, Evelyn, and I sitting together, when the conversation took a life-changing turn. My fundraising efforts for the local animal shelter had been mentioned in assembly that morning and Evelyn was noting how proud she was. As I dug into my pork bestie, she casually passed a comment: 'You raise so much money to save these dogs, Jo, but isn't it a bit weird that you eat pigs for lunch? Aren't they animals too?'

Huh? What did she just say? My mouth froze. I looked at her, looked back at my sandwich, looked back at her. Then, in that school playground, I took what would be my last ever bite of dead pig, and lunch as I knew it never looked the same again. The more I thought about it, the

more I realized that Evelyn had asked me a simple but deeply profound question. How could I eat pigs, save dogs and claim to love animals? Both pigs and dogs are intelligent creatures that possess a sophisticated nervous system, exhibit kind, nurturing qualities and, by all logical means, want to live. The only difference was my cultural conditioning towards them. It may not have been the Damascene conversion the school priest had hoped for, but there was no denying that the scales had fallen from my eyes. And it turned out that life without pork stuffing was surprisingly easy. I loved animals, the ham had been an animal, and I wasn't eating the love of my life anymore. How had I never considered this?

Fast-forward a few years and I'd finished high school, kissed a boy, grown my hair and, following a few trips abroad (which we'll discuss more in Chapter Two), moved into an apartment annexed to my father's house on an exclusive golf estate. I'd just turned pro at the game, so it was a perfect set-up. Since I also needed my own space and I'd always had a fantasy about living in the countryside, I purchased a modest cottage on the outskirts of a town two hours out of Cape Town. I fixed it up, painted the walls,

added my artistic touches. And then I went in search of the local animal shelter.

Pets are part of the suburban package deal in South Africa, and dogs in particular, as much for protection as companionship. Wherever you have a lot of dogs, you'll have a lot of unwanted dogs. That's just the way things go. It explains the extraordinary number of shelters you'll see all around the country. When you get out into the smaller towns in agricultural areas, the homeless menagerie can include just about anything, or so I'd been told, and I figured the only thing missing from my country garden was a friend for my dog Oscar (who you'll hear a lot more about in Chapter Three).

As is almost always the case, the people working the local shelter were caring and kind and didn't seem to think it strange that a city girl would leave her name and number on the adoption list with a note saying, 'Open to suggestions.' I guess they'd seen stranger things in their time. Oscar had hardly had time to mark his territory before the phone rang. Someone had handed in a (relatively) small pot-bellied pig: did I want to adopt it? A pig. Really? I'd kissed and cuddled a lot of pets in a lot

of homes, and tickled my fair share of hairy beasts behind the ear, but had absolutely no experience with living pigs. How friendly were they? Did they play fetch? Could they be house-trained? Who the heck would I turn to for the answers? Then I looked out the window and I swear I could picture the scene: Oscar, me, a gin and tonic and a pot-bellied pig. And just like that, 'Why?' quickly turned into 'Why not?' We weren't talking about raising a baby hippopotamus or giraffe here, for goodness sake, it was a little piglet. How difficult could that really be? Decision made: challenge accepted!

As I drove through the fields to collect my new best friend, I felt the emotions welling up. Rescuing animals and giving them a new lease on life was more than a passion – it was my self-diagnosed intrinsic purpose. Forget sweets and treats: in the great Black Forest cake of life, reaching out to an animal in need was my cherry on top. Despite all that, as I walked down the corridor towards a room full of yaps and growls, the nerves began to tingle. I had a last-minute thought that hadn't yet occurred to me. I was totally resolved about the adoption, but what if things didn't work out?

Typically, when you take on a rescue animal, if things go badly wrong for whatever reason, you can always 'return to sender'. Rehoming a dog isn't that hard, but a pig? That might be a stretch too far, unless the new home had a rotisserie oven – and 'mom and dad' had a hidden agenda. What was I getting myself into here, knowing I would never have it within me to return this animal to a shelter? I paused at the door and took a moment. Breathe and relax, Jo, breathe and relax. Then I strode inside, walked right up to the front of the cage and stared the pig straight in the eyes. Love would be pushing it, but I can certainly say it was 'like' at first sight. If you've never noticed it, pig eyes are eerily human and, as the saying goes, eyes are the windows to the soul. All I can say is this: we connected. I looked that pig in the eye and just knew we could make it work. No matter what. I almost, nearly, totally convinced myself of it.

With the paperwork done and the background checks complete, I collected her a few days later. In the interim, I'd made a crucial decision: her name. Apart from a small group of 'I'm-so-creative' outliers who feel comfortable sharing their homes with Darth Vader the dog or Khaleesi the cat, most pet owners go down predictable roads. There

are clichés, like Rover or Nibbles or Lassie. There are human names, such as Oscar. And there are descriptors like Ginger, Fluffy, Tiger and Spot. And at the bottom of the name drawer are the desperation names like Kitty, Tomcat, Mutt and Dawg. The ones that first-time owners resort to. For a virgin pig parent, there was only one option: hello, Piggy.

I took her straight to the cottage and she immediately got to work. Unskilled work. She literally destroyed the place: the flowers, the grass, the cushions, the couch. Nothing could stand up to the snout of that pig. To make things worse, Oscar really didn't appreciate the new kid on the block, preferring to hide in my shadow rather than risk being in the firing line of the curious hog with her penetrating eyes. I'd dealt with enough unruly puppies to know that we needed to nip the mayhem in the bud or risk a very rough ride. So the next few days and weeks were punctuated by plenty of stern words and gentle reminders that eating everything was not a balanced diet. Since I considered her as a companion like my trusty hound, she also had to get used to a collar and lead – and once we got there, the fun really started.

There are definitely a few townsfolk who still suffer from whiplash thanks to our daily walks around the block. And on the rare occasion that we went into the centre of the town for an evening stroll, I made sure to walk very slowly past the local pub and give a friendly wave to anyone leaning on the balcony railing. Nothing will sober you up faster than a dog that looks remarkably like a pig!

In time, though, I realized that Piggy was nothing at all like a dog. The relationship between (wo)man and dog is a special thing indeed, but there's seldom any doubt about who's in charge of the can opener. Piggy lived by a different set of rules. Dogs are mostly bundles of love and adoration. With Piggy, it often felt as if she was just tolerating her assigned human to buy time so she could achieve a higher goal. Like eating a chair leg.

Most of the time, I found her extremely hard to read. Yes, she wagged her tail, but she seemed to do it all the time, not only when I was rubbing her back or looking longingly into her eyes. And I always got the feeling that there was really a lot going on behind those eyes. I realized I couldn't judge her by canine standards in any way, and

the moment I did that, I began to appreciate Piggy in a completely different light.

She was a free spirit, a breath of fresh air, the star of her own show, and I felt privileged to have front-row seats. She was also a thorn in my side when she brought half the garden into the house precisely five minutes after I'd done a spring clean. Or managed to leave a neat line of hoofprints all through the house on the hottest, driest day of the year, as if she'd magically conjured up a mud puddle. And at the same time, the pure joy she extracted from life in everything she did was irresistible, inspirational, infectious. As the days became weeks and weeks turned to months, we slowly all got used to one another and learned how to co-exist in the same space. For me, a serial single mom, it was a real lesson in how to manage a 'family'.

In reality, country life was a part-time pursuit and I regularly had to return to Cape Town to bash golf balls on the range. I felt increasingly guilty leaving the poor thing alone with a random caretaker I'd hired to ensure she was fed and happy. I made a decision: the pig would have to go to town.

Getting a pig of any size into the back seat of a Mini is probably the hardest thing I've ever done, but it was by far the easiest way to meet the local residents. From the mayor to the resident alcoholic, they all came out to help. A few hours (and beers) later, we were on our way. Dog in the front seat; pig snout out the back left window, curly little tail out the right. Pig shit everywhere.

With half an hour to go before landing back at my home course in Cape Town, I ran out of petrol at about the same time as realizing I'd left my wallet in the cottage. The thing is, I remember taking it all in my stride. By then, I'd already learned that when it comes to pigs, shit happens. Sometimes it's divine shit, sometimes it's real shit, and sometimes you land in shit. You just need to keep moving so the shit doesn't stick!

I left the funny farm in the Mini, ran to the nearest petrol station, fell onto my knees and prayed before the manager. Having a kind heart and realizing that he wanted the farmyard-smelling gal out of his office sooner rather than later, he obliged . . . on one condition: 'If you really have a dog in the front seat, a pig in the back, and no wallet in sight, the tank of petrol is on me!' I was there in a tick.

Dad wasn't home when we arrived, so I took Piggy around the side and into the front garden, her new playpen. She was very at home in the country and knew the rules, but I was a bit nervous that her bad habits would return in a new environment. It was my father's house, after all, and while he had a heart of gold for animals, he still ate pork, so I wasn't certain, or even convinced, that any defence of my porcine friend's behaviour would stand up in a family court. She looked happy enough, snouting around curiously, so I went inside to clean up.

I clearly remember laughing out loud at the woman staring back at me from the bathroom mirror. Her blonde curls had transformed into freeform dreadlocks, her face was smeared with unidentified matter and her jeans were more brown than blue. The laundry room was on the side of the house, and as I stuffed my clothes into the washer and searched the shelves for detergent (extra-strength, hopefully), I was aware of happy snuffling noises coming from the garden. Nothing manic, nothing particularly 'chewy', just the sounds of a pig getting to know her space.

My turn next. As I squeezed out the shampoo, lowered the showerhead and rinsed off the craziness of the day,

I smiled at the thought of my father strolling through his garden in dungarees, sunhat at a slightly jaunty angle, waving at passing golfers with his little pink bestie at his side. Everything was going to be just fine: fairy tales do come true. How was I to know that in this case, the princess would eat the frog?

I went back outside to assess how bad the damage to the car was and quickly realized it was not a job for Jo & Hoover Ltd. Professional help was needed, and that could wait for morning. In the meantime, I'd just keep an eye on things and help Piggy acclimatize to her new surroundings. By which I mean the lawn, the flower beds, the pool and, of course, Dad's pride and joy, his rose garden. It was a thing of beauty, a carefully curated collection of Double Delights, Just Joeys and other spectacularly named specimens, pruned to perfection and resplendent in the summer sun. Until today.

What I'd heard as snuffling was nothing short of a floral massacre. The pristine patch was a battleground. A headless Ingrid Bergman lay lifeless alongside a bruised and battered Bushveld Dawn. Casanova was trampled, Fabulous Rita was anything but and

Floribundas had been flung in all directions. And there was Piggy, lying stretched out on a bed of rose petals, fast asleep. It was one of those moments when something has gone so wrong that you actually feel quite calm. Which I did – for about an hour, until Dad arrived home. To his credit, he could have lost the plot completely, but he didn't, and after a lot of promises (from me) to right the wrong and make compensation, we went about the business of working out how to try and stop something like this happening again.

Town-Piggy was obviously going to be hard to handle; the roses were just the appetiser. Next on the menu was a golf ball belonging to the club's president, followed by the fairway, a bunker and the manicured surface of a newly sodded green. Had they just tasted a little better, the golf carts would have been next. It was immediately apparent that, although I could live with my apartment turning into a pigsty, it wasn't a particularly good fit with the rules and regulations put in place to ensure that the fenced-off community got the peace and calm they'd paid for. When a letter from the homeowners' association finally arrived, I knew the party was over. Pigs were not allowed on the

estate. I had to remove the pig. And you have until the end of the month to sort it out, young lady!

Returning Piggy to the shelter was out of the question. It was difficult enough to rehome dogs, so what chance would a pig have? Besides, we'd already experienced three months together. We'd bonded, and broken bread (and a lot of other things) together. The pig had to stay, and I was determined to find a way. All that was needed was some outside-the-box thinking.

While art had been my most loved subject at school, philosophy was a close second. And, coming from a family where divorce and ongoing arguments were the natural order of things, challenging so-called authority and creative thinking were part of my genetic make-up. Within a day, I sent a reply that my co-defendant had signed with her hoof: 'Pigs have existed on this estate since its inception. Most notably between two slices of bread or alongside two fried eggs. Why must this pig be removed simply because it moves? Yours sincerely, Piggy.' The intent was serious; the argument was sound; the outcome? Surprisingly, yes – in our favour! So much so that we didn't ever receive a reply and were left to our own devices, living happily ever after.

Sure, my relationship with the estate committee was never quite the same, but the animal farm had won, and George Orwell was signalling his approval from the heavens above.

There are probably some committee members who still argue that we won the front nine, but they won the game. Keeping a pig wasn't for the faint hearted, not even for the most fanatical animal lover, and I did eventually find a home for Piggy on the neighbouring property. They already had two pigs on their smallholding, and were happy to make it a threesome. I visited her often and, every time I did, gave thanks that I'd managed to find her another home. Life went back to something resembling normal, I adopted another dog and continued trying to break par. But my love affair with pigs was officially over. I'd never eat them again, and I'd never, ever, keep one again . . .

2.
Anarchy, Asses & Annie's Song

My father was born in India in the 1930s, when the British still had an empire, and he would speak of a childhood during which riding elephants, tracking tigers and chasing peacocks were all in a day's play. His father owned all the sweet factories in the region, which explains my sugar addiction. Dad was nine years old when the Raj began to crumble, setting India on the path to independence and scattering the Poms who, to be fair, had overstayed their welcome by about 200 years. Still, for my young father

and his sister, being packed up and shipped off to South Africa must have seemed anything but. The journey took months and when they finally landed, their world was upside down.

The contrast between a rich childhood in India and the suburbs of Johannesburg was stark. Even to this day, my father doesn't talk much about it, his heart still heavy from having to leave the animals he'd so dearly loved. Clearly, a passion for animals was hard-wired into my DNA before I even took a breath – or perhaps that should be half-wired, as my mother didn't care too much for animals. Not that she disliked them; it was just obvious from the get-go that she had other priorities in life. She was ambitious, dynamic, the perfect role model of a woman who worked tirelessly to make it in a man's world, and did.

Given their obvious differences, conflict and separation were inevitable, but in retrospect, I can see the positives. Being caught in the middle of a lengthy divorce and ongoing custody battles made me a fighter, and a survivor. In a very real way, it shaped my future. Growing up, there was always an animal by my side. It was the dogs who came in and out of the family over those years who taught me

about the things that are most important to me: stability, love and friendship.

Split between parents, my childhood mostly felt like a game of ping-pong. But ever-shifting boundaries did allow me the freedom to nurture the 'wild child' within: I was independent, determined, single-minded, and competitive as hell. And I certainly wasn't going to ask permission to pursue my passions. After school sport on Saturday mornings, you'd find me volunteering at the local shelter. Everyone I knew had a dog that I'd pulled from the shelter. I was the teen who dreamed of being in the front row at London Fashion Week with a bottle of red ink in my hands, ready to protest. My bedroom was a shrine to the prevention of cruelty to animals, from anti-whaling, anti-vivisection and anti-fur placards to the kind of posters that would have made Brigitte Bardot proud.

I kept every newspaper article that involved wildlife and I was always deeply upset by any form of cruelty. I'll never forget a bizarre, horrific image I saw in a magazine when I was seven: an elephant hanging by the neck, dangling off a massive crane. It was only much later that I read the backstory. The victim was a five-ton captive Asian elephant

named Mary. A star performer of the Sparks Circus during the First World War, she was tortured and killed for defending herself against a new 'keeper' who struck her in the head with a large metal hook when she paused to eat a watermelon. The keeper died during the show and, after trying unsuccessfully to shoot her on the spot, the circus owners decided that executing her in public – hanging her using an industrial crane mounted on a railway car – was the only way to save face. The first attempt failed, sending her crashing to the ground, in agony; the second finished her off. It was heartbreaking: a picture that can't ever be unseen.

My bookcase was a library of animal stories. Richard Adams's *Watership Down* and Richard Bach's *Jonathan Livingston Seagull* are two that stand out. Humans had no empathy for animals in the former – an idea that was deeply upsetting to me – and the concept of soaring above mediocrity to make a difference was the message of the latter.

In the early '90s, when I eventually went to study at Texas A&M University in the United States on a golf scholarship, I chose wildlife and fisheries science as my major. Well, that's not entirely true: I did try a semester in

pre-veterinary medicine, which didn't go too well. I knew my life would be dedicated to helping animals, but being a creative loose cannon who hated admin and structure meant that the idea of being 'J Lefson, Doctor of Veterinary Medicine' was almost laughable.

I continued with my activism on the sidelines, decking the campus walls with my hand-drawn anti-meat posters, which didn't go down too well in what was a fairly typical Texas town. My coach eventually intervened and asked that I remove the messaging and focused on the balls instead of the bulls. It was challenging going against the grain of mainstream culture and, to be honest, a part of me was relieved about taking a break.

Texas A&M is one of largest universities in the States, and its prime focus is agriculture. In one lecture, a piglet was brought squealing and squirming into class and the professor proceeded to demonstrate how to cut off its tail and 'perform' a castration. No painkillers, no empathy, no care at all. As the bloodied bits and reproductive parts fell to the floor, the piglet's high-pitched cry pierced my eardrums. Somewhere in the distance, I could hear my fellow students clapping.

By the time I'd graduated in 1994 and returned to Cape Town, I'd decided to give golf a proper go, and might as well have set up a campsite at my local club. I spent every single day practising my short game. Just me and my headphones repeating positive affirmations and visualizing, on the tee, from Cape Town, South Africa, Joanne Lefson (cue applause), winning the US Open. It was a strange work day, involving hundreds – no, thousands – of dirty old golf balls being launched in the general direction of a pin way out yonder. Chip, land, fetch, repeat.

But there was method in the madness. My father was a gifted sportsman who, by all accounts, would have achieved a lot more on the golf course and the cricket pitch if he had just done what he was told and toed the line rather than being himself and bucking the system. (Go, Dad!) The one place they couldn't hold him back was the squash court, though, and it was there that he earned Springbok colours representing South Africa. I was determined to do whatever it took to get the badge and be a chip off the old block – literally.

Then one morning in 1995, a friend called. More accurately, an ex-boyfriend, who was trying to rekindle the

magic. He knew I was an avid (okay, obsessive) John Denver fan and, well, (don't tell anyone, but) John was in town and was going to play a round of golf, at my club! My ex had been tasked with writing an article about the musician's swing for a local golf magazine and, wanting to earn some brownie points, asked if I wanted to walk along. I had grown up with John's music; I'd even written to him as a child to thank him for inspiring me. 'The Eagle and the Hawk', 'Earth Day, Every Day', 'Windsong', 'Calypso': I knew every word of every song he'd ever sung long before I met him. His music, his activism and his 'far out' glasses: he was my man of the moment and the soundtrack to my youth.

As it turned out, John spent more time giving me the eye than working out his yardages. It was New Year's Eve, his birthday, and when we left the golf club he invited me for dinner. I said thanks and cheerio to the ex, and instead spent that summery evening sitting alongside John in his hotel suite with a bottle of vintage Dom Pérignon and a guitar. I called the tunes and he played: 'Country Roads', 'Annie's Song', 'Grandma's Feather Bed', according to Joanne's playlist. It was surreal, a serenade that would last a lifetime in the mind. Do I still have to pinch myself at the

memory? Hell yes. And I'm pretty sure my ex would say the same thing too.

John invited me to meet him in the States shortly afterwards, where I assumed the position of caddie at the AT&T Pebble Beach Pro-Am in California. A small pup in the big league, I went along for the ride and loved every single minute. Hanging out with John was a privilege, albeit a bit strange at first, considering that I was half his age and that I'd had posters of him on my wall. But as is so often the case, where some people saw differences, we saw common ground: he was an avid golfer and a dedicated environmentalist. He also happened to be Jacques Cousteau's best friend, and in 1976 he had established the Windstar Foundation, an environmental and humanitarian organization that educated people about the environment on a global scale. From our base at the iconic Pebble Beach, I caddied for him, sang with him (he said I should stick to golf), played golf with the who's who and hung out with the rich and famous. Occasionally we took to the skies in his private plane to hit the slopes in Aspen. As John said, some days are diamonds, and that's how I remember those days.

He also ate meat. I would tease him a little about it, reminding him that the majority of Amazon rainforest destruction was due to raising cows for Western appetites. He'd agree, say that he was working on it, consult the *I Ching*, but inevitably tee up the next day, write another song and move on to the next meal while I bit my tongue. Even I had to respect the boundaries. After all, he was a Grammy-winning global superstar who'd sold 30 million albums, and I couldn't even sing 'Old MacDonald' in tune.

In 1997, John was flying solo when he crashed his kit-built two-seater plane into Monterey Bay, and I was broken. Losing a loved one out of the blue is a bitter cocktail of shock and sorrow that's hard to swallow. I needed to move as far away as possible, as fast as I could, so I headed to San Diego, so-called 'birthplace of California'. Somewhere in the middle of it all, I'd earned my South African colours, so my golf game was in pretty good shape and by giving the pro ranks a try, I could remain in California and potentially sustain myself.

I can't remember how long it took for me to get back into the swing of things, but while I was hacking my way through a handful of tournaments on the mini-circuit,

I was set up on a blind date with the veterinarian for SeaWorld San Diego. He was tall, handsome and kind. He also appeared eager to settle down and get married. He proposed within 48 hours and since I figured a vet would save me millions on bills over a lifetime, I casually said, 'Sure.'

On his weekend shifts I'd often pop in to watch the orcas in training, observing a world outside opening hours and showtime that few saw. I remember times when an orca would hold a trainer underwater and release her at the very last moment. It was eerie – calculated even – and I wasn't surprised when, a few years later, I heard that a trainer in Florida had been dragged and drowned by an orca.

I don't speak fluent dolphin, but even to me, it was obvious that the captive creatures were frustrated. My husband and I had agreed never to get into the ethics of marine parks and animal captivity. His defence was that it was his job, that he was there to ensure the animals remained as healthy as possible. Fair enough. But not really. The marriage was short-lived. I felt he loved orcas more than me, and I loved dogs more than dudes; we got out of the pool and called it quits.

The years that followed were a mix of professional golf tournaments, shallow shopping sprees and as much global travel as I could sneak in. I spent a lot of time in India, exploring the country and imagining what life must have been like there in my father's time. On many occasions I was struck by the number of stray dogs and scrawny cows adorning the busy streets. It wasn't pretty, but neither is life. There was no attempt by anyone to suggest that the suffering didn't exist.

Western culture in particular seems obsessed with hiding any hint of suffering that would evoke a 'negative' response. Put on a smile and make sure all the unpleasant stuff is hidden from public view; welcome to Disneyland. Ironically, though, all you need do is peel back the plastic, peek behind the scaffold and you'll see that the suffering is the same, arguably worse. India, on the other hand, was a reality show. And even though it was sometimes difficult to witness, I appreciated the honesty of the culture. By and large, it appeared to me a land of spiritual people: willing and active participants in the ebb and flow of life. They seemed to understand suffering as an integral part of life and the *Saṃsāra*

doctrine that underpins almost all Indian religions: death, rebirth, the karmic cycle.

As the '90s gave way to a new millennium, I traversed Asia, visiting and volunteering at shelters. I went to Bhutan, where there are more dogs than people and where gross national happiness (GNH) is more highly valued than gross domestic product (GDP). The pinnacle of these travels took me to the remotest region of northern India. Ladakh is a vast, high-altitude desert landscape within the Himalayas of the Kashmir territory. With its vertiginous, harrowing road passes and outstanding vistas, it's a pristine paradise for trekkers and solitude seekers. If you're looking to find yourself, this is the perfect place to get lost. And it was here that my first foray into hands-on animal activism took shape.

Somewhere along the road to enlightenment, I'd developed a deep interest in Buddhist philosophy, and one of my reasons for being there was to photograph the remote monasteries scattered across the landscape. The town of Leh is so high altitude that on arrival you are asked to lie on your bed for at least 48 hours to enable your body to climatize. With temperatures dropping below freezing

on winter nights, it is a place of extremes, and not for the faint-hearted. As I explored the region, from the historic Old Town with its grand stone palace to the temples and side-streets, I couldn't help noticing that Leh was home to a lot of extremely unhappy-looking donkeys. Thin, neglected beasts of burden, with no one wanting to take responsibility for them, roamed the landscape looking for scraps that were hard to come by.

I noticed that most of the donkeys would gather at the garbage dump on the edge of town, consuming anything they could find, including plastic and cardboard. Many of them died from their plastic diet, others were hit by cars; those that survived were routinely beaten when they became a nuisance. I wasn't naïve to the suffering of animals and had seen my fair share of it, but for some reason, here, 3,500m up in the Himalayas, it really, really bothered me. I decided to do something about it.

I spoke to the owner of the hotel where I was staying. Being a solid Hindu, Stany agreed to help: good karma is an easy sell. Admittedly, he was perplexed as to why a young professional golfer stumbling along the road less travelled wanted to establish a donkey sanctuary in Leh,

and he wasn't the only one. We agreed that it was madness, and then got straight to business. We mapped out the plan and I provided some funding to get it off the ground, then promptly packed my bag and went walkabout in the mountains for the next two months. By the time I returned to Leh, Stany had sourced the rentable land, located carrots and (quite literally) made hay. He'd even arranged for a monk to bless the sanctuary at the official opening. We had the green light. And so it came to pass, one random day on the banks of the Indus River in a far-flung corner of Kashmir, that a team of Indians and one young South African woman marched into the desert, rounded up a herd of sorry asses and steered them into the Sanctuary for Sick and Neglected Donkeys.

I felt like I was in a Bollywood Western. Everyone who had arrived to help wore a cowboy hat, for reasons unknown, and the blockbuster day played out with music blaring from a makeshift sound system that had been brought along to add some festive atmosphere to the occasion. India truly is a country of festivals and feasts, and everyone abides by the first rule of movie supremo Shah Rukh Khan: when all else fails, crank up the sound and

boogie! The look on the faces of the locals who witnessed the scene unfolding was priceless. As we herded the donkeys through the town, the traffic came to a standstill for them, probably for the first time in its history. This was redemption day: time stopped, and people were forced to appreciate that these animals' lives mattered.

After a two-hour trek with over 100 donkeys, we arrived at the sanctuary. It was one of the best and most satisfying days of my life. Knowing that I had acted on my conviction and made a small difference gave me a profound sense of peace, gratitude and confidence. Now that the donkeys were safely havened with grass below their hooves and carrots in their bellies, I needed to move on. But I was hooked on helping animals in need, and there was so much work still to be done.

3.
And the Oscar Goes to . . .

Leaving the rocky mountains behind, I moved back to South Africa in 2004. Indefinitely. Instinctively, I headed straight to the nearest dog shelter to find my new best friend. From the moment I laid eyes on him, he stole my heart. And he was never going to pressure me for a family – bonus! He was the funniest creature I had ever seen – something fuzzy from another place in space. How did such an adorable dog end up at a shelter, I wondered? I approached the staff about the fluffball in cage B5 and

was surprised to learn that he was still available. In fact, there had been no applications and, as if the deal needed sealing, they expressed concern that he'd been at the shelter for the maximum time allowed, and we all knew what that meant. With an estimated adoption rate of 10 per cent, euthanasia rates and the unnecessary killing of adoptable dogs were, and still are, sky high in South Africa.

I completed the application and waited patiently for the home check. It didn't go well. My father's house was in one of the most exclusive private estates in Cape Town, so there was no need to protect his property with a Trump-sized border wall. For reasons both practical and optical, his wall was small: too small, apparently, to convince the inspectors that the occupant of cage B5 would be safe. It all seemed a bit silly. Yes, he had four legs, but they were short and his body was long – not the ideal physique for a high jumper. But the inspectors refused to budge. Realizing I had to act quickly, I moved into my brother's house down the road – for exactly one hour. He took his own dogs out for a walk, I plonked a few photos of my ex-husband and me on the mantelpiece and called the SPCA: there had been a gross misunderstanding, they'd gone to the wrong

house and it would be best if they could sort it all out ASAP. They came. They saw. I conquered. The dog was mine to have and to hold, and the journey of a lifetime had begun.

I took Oscar everywhere: coffee shops, golf games, dinner dates, beach walks. We were inseparable, and I don't think a day went past without someone stopping us to ask what kind of dog he was. Being a big advocate of the 'adopt, don't shop' ethos, I would just say that he was adopted. People couldn't believe that such a fine, friendly, well-behaved mutt could have come from a shelter. Rescue dog = damaged goods (supposedly). But Oscar proved the equation wrong. He attracted so much attention that my girlfriends started to hire him, because the cutest guy in the vicinity would almost certainly come over to say hi. My dog was a date-finder – Tinder on a leash. Let's go walkies!

I couldn't help thinking how different Oscar's life would have been had I not gone to the shelter that day. How many more B5s hadn't gotten their chance because people had the wrong perception of shelter dogs or bought a dog from a breeder instead? How many dogs would be

saved if people met Oscar and heard his story? I knew I was on to something. All that was needed was a genius strategy.

The answer was right in front of me. I loved travelling, seeing new places and meeting interesting people, and who better to do it with than my very best friend? Composed, disciplined, with a great sense of occasion, Oscar would, I knew, be able to handle the moment too. I did some research. No pooch had ever circumnavigated the planet: the story was there for the taking. I bought a world map and began plotting a course, never for one moment pausing to consider the enormity of the project, its cost, or minor details like quarantine. It was a good time to be a single-minded rebel with a cause. I knew I could thank my parents later for my childhood crash-course in self-sufficiency, as long as they hadn't legally disowned me by the time it was all over.

Assuming Oscar would be in the hold on flights, I focused on road and sea travel where possible, and reunited with old friends who had friends who had friends who had private jets. After months of planning, things were looking good, and I met with a local animal travel service

to ascertain how and if a dog could follow the proposed route. To my relief, the itinerary was mostly doable. I had to remove a few small islands (like Indonesia, Australia and the UK), but the rest of the world was our oyster.

We left on the 'World Woof Tour' in May 2009. Tears, flags, dog biscuits and farewell hugs surrounded us on the golf course as a helicopter swooped down to collect Oscar and me. From there we boarded a private jet waiting at Cape Town International Airport: the most budget-constrained high-flyers in history were on their way. I'd managed to get that jet, which we used for the southern African leg, and raise the necessary funds for the rest of the tour, by relying on a few basic principles that they hesitate to teach you at business school, starting with 'It's not what you know, it's who you know' and finishing with 'Who dares, wins.' The gaps in between were filled by a fistful of golf earnings and a whole lot of selling everything I owned on eBay, with the exception of my toothbrush, Oscar's bed and a bottle of tick and flea powder. A few four-leaf clovers on the greens helped too, for sure. I'm a firm believer that the world rises up to meet you when a great purpose and good planning come together.

Of course, you can't plan for everything. We'd only been on the road for 72 hours when our eagle-eyed guards at a Zambezi River lodge started screaming their heads off. I was savouring a gin and tonic; Oscar had decided to slip through the gate and go for a swim. In crocodile-infested waters. My heart pounded as the staff let slip that it would be a miracle if my dog made it back alive: 'Dog is a perfect snack for crocs.' I stood on the riverbank, screaming louder than a howler monkey. Oscar was in his element. He loved an afternoon dip, and was oblivious to any lurking peril. He paddled away, occasionally looking over at me, as if to say, 'What's all the fuss about, sister?' A few minutes felt like a lifetime and when he finally pawed his way back to shore, I felt like we'd won the lottery. I was a mess: he just danced a little waggle and took a shake. It was a stark wake-up call and I vowed that for the rest of the trip, I would make every effort to be my brother's keeper.

We headed north to Cairo and marvelled at the pyramids, howled at the Parthenon in Athens and crossed the Aegean en route to Istanbul, where we visited shelters with over 3,000 dogs. From the Eiffel Tower, the Swiss Alps and the Colosseum to a symbolic blessing at the Basilica of Saint

Francis of Assisi, we continued to sniff out the natural and cultural highlights of continental Europe. The trials and tribulations continued too. In the old Roman town of Split in Croatia, Oscar went on an extended walkabout, and we were reunited after an hour of panic. I wasn't charmed: it had only been a week since his skinny-dip in Rome's Trevi Fountain, which had helped us learn a little Italian at the local police station, a lesson that lasted just long enough for us to miss the Trans-Siberian train to Russia.

And then there was the flight from Saint Petersburg to Moscow. I had been told that whenever Oscar was in the hold of the aircraft, it was a good idea to alert the crew to check that the hold temperature was regulated. It turns out that the horror stories you hear about pets dying on flights are typically due to pilot error. This particular flight was Oscar's first long-haul, and I was a pest personified, pushing the call button to call the crew over every 15 minutes. Eventually, they insisted I go to the hold and check for myself. I hadn't known this was possible, but as luck would have it this was an old Russian aircraft, where the only thing separating a nagging blonde from her globe-trotting mutt was a hatch at the back of the cabin. Bring on

the caviar and champagne! Seeing Oscar in his blue travel
box, wagging his tail when I called his name, reassured
me that he was fine in the hold. Not ideal, but it wasn't as
if the humans were fully reclined either. And if that was
the extent of the lack of creature comforts we'd have to
overcome to see new places and create awareness around
rescue animals, a cause we cared about so deeply, then it
was certainly an acceptable compromise.

India, perhaps not surprisingly given my previous
experiences there, was the highlight of the Asian leg.
Trekking the land of Mahatma Gandhi proved to be
invigorating, enlightening and introspective as we
swam in the Holy Ganges, snuck into the Taj Mahal and
recuperated at the donkey sanctuary in Leh. I had always
marvelled at the way a man so small in stature, armed
only with a dhoti and a shawl, could leave such a massive,
non-violent footprint in his beloved land. There's a famous
quote attributed to Gandhi that goes: 'The greatness of a
nation and its moral progress can be judged by the way its
animals are treated.' I can't remember how many times
I'd used these words in conversation, in my own journal
writings and on those controversial campus posters!

If India was inspiring, China was nerve-racking. According to World Animal Protection's 2020 report, even in the age of COVID, animal welfare doesn't fall into the portfolio of any government agency and there are still no national laws that prohibit the mistreatment of animals. Though animal activism is certainly on the rise in the country, Humane Society International estimates that 30 million dogs, mostly strays and stolen pets, still suffer to satisfy the appetite for dog meat across Asia every year. Not surprisingly, we had security wherever we went. Only dogs of a certain height or size were allowed in some cities, and I was warned that any attempt to rescue a dog from a meat market would be doomed. Getting Oscar up the Great Wall of China for the snapshot of all snapshots was a calculated risk. Fortunately, the element of surprise worked in our favour, and the guards protecting the main entrance allowed us in. We got a photo, had a laugh and booked a ticket for the first plane out of there.

Compared to the crush and chaos of Beijing and its 20 million inhabitants, landing in California felt like we'd discovered Disneyland – and we had. Goofy, Peter Pan and 'It's a Small World After All', Oscar loved it all. We surfed

Santa Monica, cruised the coastline, revisited Pebble Beach and got front-row seats at the *Pets Ahoy* show at SeaWorld and its cast of rescue animals from local shelters. And then we drove across America. Boy, did we drive: from the Grand Canyon and Monument Valley down Route 66 to Vegas, where we couldn't resist the ultimate photo op. Yes, we got married by Elvis in a neon-lit chapel deep in the heart of Sin City. It was all about creating unique stories that would then reveal our greater mission: to draw people in with something never seen before and have the penny drop about animal welfare by the time they left. What happens in Vegas supposedly stays in Vegas, but of all the adventures we had on tour, this one created the most hype.

Next, we headed south for Costa Rica and the Caribbean, which left only one continent standing between us and the finishing line. I had only ever been to South America once, on a brief sight-seeing holiday back in 2002. Patagonia is the wildest place on earth I've ever been to. It also holds the record for the most expensive can of Coke I've ever bought, at a whopping ten US dollars. The Andes aside, I wasn't expecting the fourth biggest

continent to be a land of such extremes. We escaped to the Amazon, explored the rainforest, dodged pythons and hung out with sloths. We played soccer with the locals and visited what must be the most isolated dog shelter on the planet: Amazon Cares near Iquitos in Peru, which is only accessible by speedboat.

Our last expedition was Machu Picchu, but not before having Oscar hide out in my suitcase, as dogs were absolutely not allowed on the train to the hike's starting point. It was either that or he'd have to walk the hot, humid trail for days and, knowing his hiding wasn't going to hurt or disrupt anyone, it was an executive decision I humbly took in the name of my own animal's rights. We managed fine, although his silent-yet-deadly flatulence that day had the passengers giving me dirty looks all the way up the mountain pass. Then finally we crossed the Americas. By this stage Oscar, now something of a media darling, was reaping the benefits of fame, and sat right next to me, enjoying the in-flight cabin service as we landed under the sun on Copacabana Beach. Despite being afraid of heights, I even hang-glided with Oscar over Rio, with Christ the Redeemer looking after us and pointing the way home.

What an extraordinary adventure: nine months, five continents and 43 countries. When we arrived back in Cape Town in December 2009, Oscar sniffed the garden tree, walked into the house and took a nap. He had taken the travel in his stride, as if destined to do it; he'd made his point and grabbed the headlines with all his undeniable charm. Not a day went by without me looking him in the eye, stroking his soft fur and thanking the stars above that he was in my life. My world felt complete, and I wondered how I'd ever make it without him by my side.

In the years that followed, I wrote a book – *Ahound the World: My Travels with Oscar* – and did two tours of South Africa to give talks about our travels and raise money for local shelters. We flew a dog-shaped hot-air balloon called Oscar Maximus across the skies and visited hundreds of schools across the country to inspire pet adoption. Besides getting their paw-signed book, all the kids ever wanted to know was, if we really did get married, why wasn't I wearing a wedding ring?

We returned to India on a few occasions, and divided the rest of our time between Cape Town and California, where a moment of weakness and an online dating platform had

turned into a marriage proposal and a wedding ring. But I think I knew from the start we were loving, honouring and obeying on borrowed time. He had a house full of kids and I had a heart full of fluff. There was only one man I'd want riding shotgun, and that was Oscar. He could sit in a plane for 20-plus hours without ever needing to lift his leg, and could charm his way through immigration in minutes when on my own it would have taken hours.

In the middle of 2012, I started working on our next adventure: Expedition Mutt Everest. Oscar would become the first documented dog ever to go to base camp. It was going to be epic, and we were living the best life. We had purpose, we had passion, we had plans and, most of all, we had each other. And then, on a Friday evening in February 2013 in San Martin, California, the unthinkable happened.

4.
Somewhere Over the Rainbow

All I felt was a small bump under the back right wheel of my car, which was followed by a loud, agonizing groan. It was our habit to let Oscar out of the car at the entrance gate of my house so that he could run inside, and this day was like any other. But when I looked in my rear-view mirror there he was, lying on the tarmac. He was moving, but clearly in distress. Confusion and chaos collided with panic and prayer; my husband placed him gently in the car, and we were at the vet within minutes.

I ran inside, Oscar in my arms. He seemed okay. There was no blood. I prayed he'd get settled in, sorted out and we'd be home before we knew it. Much of what happened in the next hour still haunts me to this day. He lay on the table. I stood a distance away, watching, wondering, wishing it was all just a bad dream. Then blood started to come out of his mouth, and it wouldn't stop. The vet frantically tried to place a tube down his throat, but it was clear that things were deteriorating rapidly. I kept asking, 'Will he be all right? He'll be all right?' I could sense the vet knew she was losing the fight. I remember Oscar looking me straight in the eyes. I looked right back. I've never felt so helpless. In a matter of moments, his eyes slowly closed. He was gone.

It was a cold, crisp Friday evening and I recall walking back to the house, disorientated, but everything else is a haze. I couldn't think, and I couldn't believe what had just happened. I called my parents. My mother cried, my father too. What could anyone say? No amount of wishing, wanting, crying or consoling could change anything. In one second, my pride, purpose, passion and my very reason for living and loving life, had vanished.

My deepest wish had always been to see Oscar grow old and live out his days napping in the shade of the old willow tree that wept above our humble home in Cape Town. We would reflect on a life well lived and when the time came, I'd hold him closely, thank him, honour him and let him drift away, peacefully. We'd travelled over 100,000km together and lived to tell the tale. We'd microlighted, hitched on tuk tuks, cruised on camels, dodged crocodiles and swum with sharks, so his manner of death was a terrible and twisted irony. It just seemed so incredibly unfair, and I hated myself for it.

'In retrospect' has never really been my thing, but even I have to admit that I lacked the tools to deal with the situation. Most days it was unbearable and I found it difficult to function. It was more than shock; I had sunk into a deep depression, a dark, emotional dungeon. I had countless conversations with myself about the meaning of life, how the world carries on oblivious to tragedy, how you can't unfry an egg. I questioned the things that had brought me pleasure and fed my soul, and lambasted the things that didn't: the trivial conversations, the wasted time. I packed my bags, ended my five-month marriage

and, within a week of that fateful day, I had landed back in Cape Town. I needed to be alone. I needed to go inside.

As time passed and the letters of sympathy slowed, I started to paint. I found solace in painting large, lifelike portraits of Oscar, slowly stroking the brush across the canvas. As the tears and the paint flowed, the healing began. I listened to music and I listened to my silence. I slowly began to reconnect with myself, and the outside world, one small step at a time. And, of all the inner voices vying for attention, the one shouting the loudest was the independent child that had always been my protector: the fighter, the competitor, the survivor. As I went through the classic stages of grief; as the sadness, guilt and anxiety slowly morphed into feelings of anger, then acceptance and hope, light broke through the cracks. I was overcome with an intense, burning desire to rewrite the script and give my tear-jerker a happy ending. More than that, it had to be something meaningful, something worthwhile: something good.

When the idea came, there were no crashing cymbals or bolts of lightning. A simple vision: to establish the world's most inspiring adoption centre as a testament to the dog

that changed my life. This would symbolize my gratitude for having had Oscar in my life and serve as a form of redemption, transforming despair into hope in the most profound way. For the first time in what seemed like ages, I pulled myself towards myself and went for a drive.

The hunt was on for a special piece of land to build Oscars Arc – which is what I'd decided to name the centre – and I aimed in the general direction of the Franschhoek valley outside Cape Town, home to some of the most sought-after farmland in the country. It was here that the likes of Oprah and Sir Elton John vacationed, and where Richard Branson had his own wine farm: a tourism spot so hot it has its own tram system. I reasoned that if this shelter was going to raise the bar, it had to be perfectly positioned for that. I pulled into the historic town and took a few turns. I followed my gut. At the end of a quiet country road on the edge of town, I stopped my car. There, before me, dangling from a rusted gate, was the sign I'd been looking for: FOR SALE. Behind it, a neglected smallholding. It was obvious no one had lived there for years. An old farmhouse stood in the centre of the site, surrounded by large trees and an avenue of oaks that whispered of a long and illustrious

past. The building stood proud, its foundations majestic, magnificent. I knew immediately that this was the place to build Oscar's legacy.

While I'd found a way to travel the world and live the life of Riley, the richness of my experience in no way matched my bank account. The asking price wasn't just high, it was stratospheric: mission impossible for me, or my family, to fund. When I called my mother from the site and told her what I had found, she told me to stop dreaming and hung up the phone. But for me, making the dream come true wasn't up for discussion. I headed home and immediately went searching for my little black book.

Perhaps it was all the positive affirmation techniques I'd learned in the sports psychology classes at university, or maybe Tony Robbins's *Awaken the Giant Within* audiobooks had actually worked, but I have always had a strong belief in my missions. I trust the universe to find a way, having faith that it will conspire in my favour if the purpose is true. And I truly believe it was this conviction that had a material influence on the way in which everything unfolded in the months that followed. It was hardly a nuanced situation: I needed money. Possibly a

miracle. Or perhaps I just needed to find the details of that nice German gentleman I'd met back in the days when I was teaching golf in Cologne. He had taken a liking to me and I just had a gut feeling that my project and his ideals would make a good fit. One call led to another and, within a few weeks, Harald had given me the deposit needed to secure the purchase of the property.

At the time I was so focused on the end goal I didn't really stop to think, but in retrospect, what Harald did was quite extraordinary. He didn't ask many questions at all, so I figured he was either a good listener, we were hopelessly lost in translation, or my fast-rambling English had simply fried his brain into silence. Either way, he understood what I needed and his generosity was extraordinary. A formal contract? No need. Surety? Don't worry. I think he realized how passionate I was, how urgent the situation was, and that there was no hint of a hidden agenda. He really, genuinely just wanted to help. I did write a letter stating he could have a small property in Cape Town that I owned if I never repaid the loan, but nothing formal enough for him to ever have held up a victory trophy if there was a legal dispute. And understandably, he wanted

equal shares in the property, which was absolutely fine with me. I knew the universe was on my side and besides, once my mattress was on the floor, I would never be an easy cookie to move. Possession might be nine-tenths of the law, but in South Africa, occupation is everything. There are people on Gumtree who won't let a used pair of underpants leave their closet without seeing the money in their bank account first. And yet here I was, receiving an unsecured gift of millions, and I could have run a mile. Harald's trust in me was hugely self-affirming, but I had also undergone a significant change in my outlook on life. I had a real sense about how vulnerable we all are, how short and unpredictable life can be. If you have a mission, best you put all your regrets and fears aside and get on with it.

I quit the coffees, the social gatherings and the small talk. I lost touch with a lot of friends and found a way to consciously reshape my life. I didn't just want to live; I wanted my life to matter. And as everything could change in a second, I wanted to give everything I could before it was too late. Too often we are forced to suspend our dreams and wait for *that day* to come along, but Harald had given me an extraordinary blessing: I didn't have to

wait. And I was motivated by immeasurable gratitude for having the chance to start again.

I still hadn't worked out exactly how I was going to fund the building and completion of the project, but I knew it would happen. As the transfer moved ahead and the designs unfolded, I continued to plan and paint, reflect and reimagine. I grew closer to Harald, who had started splitting his time between his house in Cape Town and his home in Cologne. I got the impression that Franschhoek and all my creative ideas inspired him and so, in a very real way, I was also helping him. He was also at a turning point in his life: he was deciding whether to leave Cape Town altogether and return to Germany on a permanent basis. It was the least I could do – he had not only changed my destiny, but also proved a source of constant inspiration. I'll never forget his reflections on losing his second wife, Anke, to cancer when she was barely 40. She was a strong, fit, beautiful woman, embracing the promise of an abundant life filled with infinite possibilities. A pain in her back one morning led to a scan a few weeks later, and the devastating news. For a year and a half, she battled a rare form of cancer from a hospital bed in Munich and, despite

having the best medical care in the world, and Harald by her side at every moment, she finally succumbed. On the rare occasions that he discussed or reflected on these moments, it had a profound effect on me. He was so deeply at peace with it, letting go of what he couldn't change and gently acknowledging the enormity of the lessons learned under the most traumatic of circumstances. The cycle of life, death, rebirth.

I flew to India a few times over the course of that year, further exploring teachings of enlightenment, gratitude and acceptance, and spending time at the donkey sanctuary. It was also here, while filming a documentary about the sanctuary for the Cannes Film Festival, that a stray, emaciated puppy stumbled towards me and collapsed in my lap. Months later, I succeeded in taking Rupee to Everest's base camp in Oscar's honour. I eventually flew him back to Cape Town, where he was adopted by my mother. To this day, Rupee continues his quest to rid the planet of plastic bottles by consuming every single one he gets hold of or, at the very least, shredding it to pieces on the living room floor.

A private road divided the Franschhoek property in two,

and while I knew that Oscars Arc would be developed on one side, I didn't have a vision for the other. It comprised four hectares covered in weeds, molehills and guinea fowl. A driving range came to mind, but my interest in golf had long since waned. Gradually the pieces fell into place. I'd always wanted to rescue farm animals and provide them with a safe haven. Nothing extravagant, just a small flock or two of lost sheep so that friends (and friends of friends) could visit and connect with them: a place to create positive encounters between consumers and farm animals beyond the supermarket shelves. My objective wasn't to judge anyone, or to send people who eat meat to meditate behind the back legs of a nervous donkey. It would be a place to inspire compassion and empathy for our fellow creatures, and hopefully encourage people to question whether they had been pulling on the wrong side of the food chain. While living in California I had visited the Farm Sanctuary animal shelter in Acton, where I learned that I was not very effective at scooping poop. I'd also signed up to intern at Animal Place in Grass Valley, but that had lasted only a few days, as my back couldn't hold out under the weight of moving hay all day.

Fuelled by those memories, I sketched up some basic designs for a barn. Nothing big, just enough for a cow, a goat and a pig or two, maybe three. I sent it off to a draughtsman, submitted it to council and within a few months I was ready to start. By this stage, my relationship with Harald had progressed well past the farm gate, and he agreed to lend me some more moolah to get the project started. As the foundations went down and the beams went up, one thing became obvious: the barn was three times the size I'd imagined. The neighbours would have been forgiven for thinking that Noah was prepping for another deluge.

Call it beginner's luck, but the barn turned out perfectly. It exuded charm and fantasy, like something from a movie set where you'd expect to find dogs playing poker with sheep or a talking spider waiting to welcome you inside. The permanent residents would hang out in their stalls on either side of the barn, and the centre was sectioned off to allow visitors to meet them or explore the rest of the barn without getting in their way. The double-volume ceiling and high side windows let in plenty of light, and a grass roof ensured warmth and green-minded sustainability.

And then there was the upper loft area. I'd designed it to store hay, but when I first stood up there, I knew it had to be a bedroom. The entire facade of the wall was glass, showcasing a panorama of soaring mountains, held together with thick industrial steel frames in the shape of sunrays. It was a magical, enchanting space. By accident I had created a beautiful monster. This was obviously too big to be a hobby or side hustle. Although the vision and mission were clear, the project needed a bigger picture, a more formal game plan and a strategy built on the dual pillars of sustainability and responsibility. And that's how, at the beginning of 2016, Farm Sanctuary SA became a reality: a registered NPO that aimed to inspire compassion for farmed animals. And the first order of business was to organize a rescue party . . .

5.
This Little Piggie Went to . . .

In my mind, the headline read: 'Undercover animal activist agent creeps into factory-farming operation, rescues two piglets from jaws of hell.' In reality there was a Mini Cooper barrelling down a dirt road with a sack and a blanket in the back seat, driven by an ex-pro golfer with long, bleached hair, doing carpool karaoke with Freddie Mercury belting out 'Under Pressure'. I wasn't going to do any damage, nor was I a threat to anyone: I was far too much of a chicken. In childhood, the tension during hide-and-seek

was invariably too much for me and in adulthood, I have always preferred watching David Attenborough's birds over Alfred Hitchcock's. But with faith on my side and a heart full of good intent, I believed I could charm my way through any challenge I encountered on my mission.

When it comes to industrialized farming, South Africa has really arrived. Even in the pristine surrounds of Franschhoek, there are plenty of hog farms over hills and down dales. They tend to be set back from highways and, because they are essentially factory buildings, can easily be mistaken for huge tool sheds. In short, while they look a lot more rural than the shiny high-tech operations of the developed world, the principles are identical: cram in as many animals per square metre as you possibly can; subject them to whatever is needed to keep them alive; grow them as fast as possible; slaughter them as soon as it's commercially viable. That's it in a nutshell. Old MacDonald's farm is, I'm afraid, the exception, not the norm. The vast majority of meat consumed is defined by scarcity for the animals: no herd, no hay, no sunshine, no life.

Aesthetics aside, the primary difference at the tip of Africa was that there were no 'ag-gag' (anti-whistleblower)

laws, as there are in some states of the United States. These regulations outlaw any form of undercover investigation that reveals abuses on farms. Some states mainly target people working on the farms, but others, like Kansas, went to extraordinary lengths, trying to make it a criminal offence to enter any animal facility with the intention of taking pictures or making a video. Why such draconian laws? And why no similar laws relating to apple orchards or strawberry farms? Because the owners of these businesses know that if consumers saw how their food was being raised, farm factories wouldn't exist. The other difference between the US and South Africa is more subtle: since factory farms here were still, for the most part, hidden away from public view, and there had never been any major incidents where activists had broken in and exposed the dealings inside, security was sparse. Or non-existent.

I already knew exactly where I was heading. Months earlier, I'd connected with a Zimbabwean man called Tinashe and commissioned him to convert some old barbed wire lying around the farm into animal sculptures. When he reached out for more work, I asked if he wanted to join the revolution and go undercover. Having insider

knowledge would make things a heck of a lot easier. It turned out that Tinashe was a likeable chap, people were naturally drawn to his calm demeanour, and it took two days at the very first hog farm he'd walked into before he was offered a promotion. As official manager, he got an instant pay raise and the keys to the door. He was happy, I was ecstatic. Sure, I had nightmares about my friend and colleague becoming the most successful captive pig farm manager in the land, but I also knew he loved animals. So there he was, Robin to my Batgirl, answering the call of duty.

We pulled up to the farm. It was a late Sunday afternoon in May 2016, Tinashe's day off, and the pearly gates to hell were open. I parked the car, grabbed my pepper spray and camera, and started to look around. The first building we walked into was one large concrete space. It was divided up into a dozen or so smaller sections, in each of which hundreds of piglets, crammed together, shuffled around on filthy, cold, damp floors. There was urine and manure everywhere. The stench was overwhelming. In one of the pens lay a large sow, squashed into a tight-fitting cage where she wasn't able to move at all. Outside the walls

of her farrowing crate, her piglets scurried around. The industry argues that farrowing crates isolate the mother so the piglets aren't hurt when she moves around. In reality it's a solution to a problem that wouldn't exist if there was enough space: in order to cram as many pigs and piglets as possible into one space, and still prevent any 'damage', they restrain her movement completely.

Financially, it's a lot more efficient to compromise the quality of life of these pigs than to provide them with more space. As a result, these sows spend the vast majority of their short, torrid lives confined to these crates. Imagine being strapped down to the middle seat on an economy flight with no leg room. And you're not allowed to get up and go to the bathroom. Forever. And your only out is that, when your ability to reproduce finally declines, you are released, loaded onto a truck and sent to slaughter. All together now: 'With an oink-oink here and an oink-oink there, ee-i-ee-i-o.'

I walked to the next building, and it was more of the same. And so it went on, building after building: thousands and thousands of pigs, born and raised in vile conditions and sent to slaughter after six torturous months. A protein

production line without a hint of empathy. The smell was getting to me. It was frying my brain. My battery was on low. Concentrate, focus: catch two pigs and get the hell out of here.

When he finally made an appearance, the manager on duty wasn't too fazed with our presence, and he looked rather confused when I asked him if I could please take two pigs. It was either the worst attempted robbery or the politest undercover operation in history. In the end, all it took was some gentle persuasion (50 bucks, in other words) and seconds later I was slipping and sliding across a skating rink of excrement trying to catch a pig. I always had great touch on the golf course, but this was a different ball game. Piglets are fast. And agile. And loud. Boy, are they loud. So much so that every time I got one in my arms, the squeal frightened me enough to make me let go. In case you didn't know, a pig's squeal can top 100 decibels. That's as loud as a chain saw, or a clap of thunder. Tinashe jumped in to help and, realizing that he was now on the payroll, the manager did too. What ensued was a frenetic mud wrestle: pigs flying everywhere, the three of us, tripping over each other, trying to get hold of one of the critters without

waking the neighbours. Finally, with two in the bag, we ran out, popped them in the car and got out of there as fast as we could. By the time we pulled in to the sanctuary gates, the Mini was a convertible septic tank and any hint of personal grooming was out the window. I remember looking at myself in the mirror and thinking, 'Best you get used to this, ma'am, 'cos it's only the beginning!'

We let the pigs out, and from the second their hooves touched the wooden floor, they were unstoppable. All their pent-up energy from being trapped in an overcrowded concrete dump was unleashed. They were both very small (no more than four weeks old), both female, with their tails cut off and an appetite beyond human comprehension. Perhaps I'd blocked out the memory of my first porcine companion, the golf estate committee and my promise-to-self to *never* do it again. I feared for the barn itself: left to their own devices, these animals will literally eat you out of house and home. In desperation, we placed them in a stall for the night, they finally settled down and we all called it a day. It was their first night on hay with space to lie down: the first best night's sleep of the rest of their lives.

The next morning, they were woken by John, who I'd

formally appointed as caretaker, feeder and, hopefully, pig whisperer. He was born in Malawi and when I first bought the farm, he was the entire staff complement, hired to act as a roaming security guard while the place sat vacant. He was there the first time I set foot on the property, sitting in the shade, quiet and polite. I liked him the moment we met and when the transfer took place, it was a mutual decision to stay 'together'. He loved animals and exuded a natural warmth towards them; plus he was keen to stay in the area. Most of all, I knew it would take a team of caring individuals to make this work.

My dog adoption project, Oscars Arc, was taking shape on the main section of the property. The office was up, the pop-up mobile adoption centres made from converted shipping containers were in full production, and the first call to a local shelter loomed. The concept was simple enough: I'd take dogs from overcrowded shelters and place the mobile adoption centres both on my property and in high-footfall public locations around Cape Town. Taking dogs that were desperate to find a home direct to the people was a concept I knew could work. It just needed focus, which meant that the project took up a lot of my time, but it

didn't stop me checking in regularly to see how our guests were doing at the Farm Sanctuary next door.

From the get-go, it was notable how different in personality the two pigs were. One was gentle, inquisitive and had a soft expression in her eyes. She also had a healthy appetite. The other was more dominant and obsessed with hoovering up anything, with or without nutritional value: dust, flooring, gates, iPhones, you name it. I had done enough research to know that pigs in the wild develop complex social structures, learn from each other and love to play as much as – possibly even more than – woman's best friend. What's more, on the scale with which we measure intelligence, pigs generally rank fifth, after humans, chimps, dolphins and elephants. They have been the subject of academic enquiry for decades, including experiments in 2021 at Purdue University in the US, where researchers discovered that they could train pigs to play video games, controlling a joystick with their snouts to hit moving targets, in order to get treats. And when the treats ran out, they kept playing anyway. Think about that for a second.

Bottom line: I needed to keep them entertained, but

I didn't have the time or inclination to hook up a PlayStation. During the day they'd play and socialize, and at times I'd separate them and try to encourage their individual sporting skills with a variety of soccer balls, rugby balls, tennis balls and Frisbees. Rosie ate or destroyed everything within a few minutes, blowing her lifetime budget for playground paraphernalia in a single day. The other pig, whom I hadn't yet named, was better behaved but inevitably ended up also doing what pigs do: chewing everything withing trotter's reach. With one exception. The builders had cleaned up neatly when they finished, but had left behind an old paintbrush, which I casually chucked into our play session one day. She nudged it, sized it up, prodded it and seemed genuinely intrigued. While everything else was fair game, the brush was protected, nurtured even, like a security blanket with bristles. Was she channelling the spirit of Francis Bacon? Either way, she had just made a name for herself: Pigcasso. Then she picked up the brush. For 20, maybe 30, seconds, she just stood there as if to say, 'What next?' and then dropped it gently back to the floor.

Now I've always had a fertile imagination. I see dragons

in the hilltops and druids in the clouds. But in that moment I couldn't help wondering: if the pig could pick up the brush that gently, with intent, would it be possible that she could actually paint? After all, we had a whole barn's worth of walls to fill, and why pay for someone else's art when we could do it ourselves? I could see it all playing out in front of me as if it had already happened. And then I snapped out of it. A painting pig? Really, Jo, don't be ridiculous. I genuinely laughed at myself. Put that thought where it belongs and get back to business. For the next month, in addition to a regular schedule of deep sleep and mud wallowing, Pigcasso spent most of her time expanding. Not her mind, her body. It was remarkable – you could almost see her grow in real time. But no matter how hard I tried to forget the painting pig idea, it seemed like she wouldn't let me. She spent an inordinate amount of time gently playing with that darn paintbrush. The two were inseparable. Like a chicken and its egg, she protected it from harm and defended it from Rosie as if her life depended on it.

I started to put some flesh on the bones of the idea. What if we approached it more like a project, an art project that aimed to explore and celebrate the essence of

a pig? Imagine if we could do something that highlighted the plight of factory-farmed pigs, but do it in a way that engaged people in a positive way? I stopped chuckling inside. My curiosity was piqued. What if we could do something that had never been done before? And it just so happened I had a specialist on speed dial. I had been working with an animal behaviourist named Barbara, who was assisting me with the dogs, and she seemed the perfect person to analyse Pigcasso's creative potential. Given the opportunity – and if she desired it, of course – could my pig prodigy be inspired to, well, study art?

I could sense what Barbara was thinking: 'For goodness' sake, I didn't come here to help choreograph the moves of Vincent van Hog!' Still, she was happy to lend a professional opinion and confirmed what we both already knew: we were dealing with a distinctly intelligent creature who was naturally curious, so who knew what was possible. Whether Barbara believed Pigcasso could paint the Louvre pink, well, I didn't want to ask, lest she lose faith before we'd even begun. Personally, I knew it was just a matter of time. The creative within me drooled at the prospect. Besides philosophy, art was the only

'A' I ever got in class. My watercolour box followed me everywhere I went. I even recall my dad arranging for me to meet Tony Hart when he vacationed in South Africa in the early 1980s. He was an English artist and educator and quite a big deal, with a children's TV show on the BBC called *Take Hart* that featured Morph, a clay stop-motion character who was everyone's favourite. Tony and I painted together and he shared my artwork on his show. I'm not sure anyone really cared about my two seconds of fame, except maybe for Morph and my father, who was convinced I was on my way to being invited by the Queen to paint Buckingham Palace. But the experience made a massive impression on me and lit an artistic flame that's never gone out.

And so the idea took shape. Developing Pigcasso into a painter was an artistic endeavour in itself, and potentially a lot more ambitious than painting myself. It was exactly the kind of challenge I enjoy. Moreover, I'd been struggling with a business model to make my non-profit sustainable. Could this be it? Most importantly, if this pig could paint, it was guaranteed to attract some healthy attention for the sanctuary and any animals in our care. In short, another

opportunity to leverage the 'Oscar effect'? To be clear, even at that stage, it was always intended to be a serious project. I remember being quite irritated by a few friends I shared the concept with early on, who thought that the idea of giving visitors to the valley a good laugh in between wine tastings was a fabulous idea. No way, people: this was an acorn that would allow my creative juices – and with luck, a pig's potential – to develop into an oak tree, a serious artistic endeavour that would conquer the world. We just had a few practical issues to solve.

I began by designing Pigcasso's paintbrushes, as they needed to fit comfortably into her mouth. I went to a local hardware store, bought some basic brushes and worked out how to pimp them up to our requirements. First I taped toilet-paper tubes to the brush's slender wooden handle, then covered it with the kind of foam tape you'd use to regrip a tennis-racket handle. Hmm, not bad. I placed a few brushes in her stall, stood back and held thumbs (some people cross their fingers for luck, but in South Africa, we hold our thumbs). There was always the risk that she'd treat them like tortillas, but to my delight, she immediately picked one up. Result! She tossed them about, placed them

in her mouth and shook her head from side to side and up and down.

Of course I was biased, like any proud mum, but I felt we were off to a flying start. Pigcasso showed potential and I was there to help her fulfil it. Game on. It was time to grab the credit card and find an art shop. The former was a necessary evil, the latter was pure joy. Art shops remind me of candy stores, their shelves overflowing with possibility and temptation. Showing remarkable restraint, I packed a single trolley with a few small canvases, an adjustable easel and a selection of non-toxic paints. I was focused, single-minded, mildly obsessed. When I arrived back at the barn, I walked in and dropped the shopping bags at the hooves of my student. 'Pigcasso,' I called, 'ready to make history?' She rolled her head to one side, eyeballed me and went straight back to sleep.

6.
How Much Is That Piggie in the Window?

In no time at all, the sanctuary transitioned from barn to artist's studio. Not just any studio, but a painting pig's studio. The only one in the world. All I needed was, well, the painting pig. With some positive reinforcement, a hell of a lot of paint and a bit of help from Claire, the process began to unfold. I'd hired Claire to work with the adopted dogs that would be arriving on the property, but with my hands full, no dogs yet, and a pig in need of

art classes, I decided to introduce them to one another and give them something to do. What was needed was a bit of patience as Pigcasso got the hang of picking up a brush and taking it to the canvas. Of course there was no way to teach her a style of painting (maybe there was, but that wasn't the concept here!), but if she could wilfully, on her own accord, walk to a brush dipped in paint and know that there was a canvas above, what magic might happen?

It turned out that picking up the brush from a pot of paint came naturally to Pigcasso. Getting her to dance it across a canvas took a bit more time and a few antics on my part. I could lead by example, but ultimately it was up to her what style she would develop. Suffice it to say that, incentivized by a few grapes and subjected to a series of one-on-one lessons involving me on my hands and knees with a brush in my mouth, she caught on pretty quickly. And it was a relief, too. After all, I knew that I could teach a pig to pick up a custom brush and arrive at the canvas, but teaching a pig to physically paint was a step too far. That would have to come from somewhere deep within: from somewhere only she could find. Once the

penny dropped and she understood what to do, Pigcasso owned the canvas. Pablo, watch out.

My role was to ensure that she had the right colours, the right brushes and a fitted easel. The last two were easy enough, but the first was going to be interesting. Unlike humans and several other primates who have trichromatic vision, pigs have dichromatic vision: unable to differentiate red-spectrum light, their colour perception is limited. Other than that, all we needed was a constant supply of spinach and avocados to ensure she didn't run out of gas, and a small training device called a clicker, because unless she was eating or sleeping, Pigcasso was easily distracted. The clicker is based on a Pavlovian technique, using a click sound and reward to reinforce a particular behaviour. Brutally simple and 100 per cent painless, it's the kind of 'technology' that every parent in the world should know about. If they were available in aisle five at your local supermarket, they'd be sold out before the sodas and chips. Seriously. The clicker allowed me to establish a routine for Pigcasso between setting everything up and her grabbing the brush. And once she had it in her mouth, it was like a rainbow appearing on a sunny day. Pure animal magic.

Each small step felt like a long jump in the right direction, but she always knew she was the boss. If she felt like sleeping in for a few days, she did. If she wanted to eat canvas for breakfast, I gave her a napkin. She could live her life on her own terms, arriving at the easel if and when she wanted to and still get the same five-star treatment. Priority number one was ensuring she could live out her days as nature intended: hay below, sunshine above, compassion everywhere. By now, everything I owned was covered in paint: jeans and shoes, scarves and underwear. Nothing was safe. I would even find paint up my nose. The fact that my profession had turned into PA to Pig, well, no one had to know, although the neighbours had started calling me 'the pig mamma'. I shopped for Pigcasso, set the stage for her, cleaned up after her and cooked for her. I could count the times I'd cooked for myself on one hand and here I was, scaling up to Masterchef recipes to keep my boss happy. There were times when she'd lie there, Caesar-like, and look at me with a raised eyebrow as if to say, 'All hail, me! More grapes, please.'

Her artwork at the time appeared pretty random, lacking any sense of structure, form or flow. I knew it needed a lot

of refining, but we had time on our hands and there had never been any guarantee that this would go anywhere. And she was still so young – three months old at best. But man, were we having fun! Canvas after canvas, tube after tube, the two of us couldn't get enough. Even Rosie got involved, assisting by shredding and trying to swallow the rejected artworks, while I kept any that showed some merit and pinned them to the barn walls.

Day after day, week after week, Pigcasso pressed on. She wielded the brush with unbridled enthusiasm, her head moving frantically in all directions, a bobblehead on hooves. If her ears had been wings, she'd have lifted off. She was free to go with her own flow, wherever it went, and as she grew, her artworks did too. Although I had to sense-check myself every day, it was undeniable: the shadows were becoming shapes, there was order emerging from chaos. I couldn't help feeling that this was more than a passing phase in a pig's diary. I'd seen art created by animals before and, while delightful, it was still childlike. I have always enjoyed the argument made by non-art lovers who look at a piece of modern art – like Mondrian's primary-coloured squares or Pollock's splats – and say,

'Yeah, but anyone could do that!' And then 'anyone' tries it and you know what, it looks like nothing. Because there's an underlying intent, a *raison d'être* behind real art that is anything but random. And when you're faced with random strokes upon random strokes, you may well end up with something visually interesting, but for me it's obvious when something's simply an accidental mess. That was not what we were searching for.

What was extraordinary about the initial development of Pigcasso's style was that, very quickly, her art was developing a visual structure that had form, shape and obvious control. Haphazard? Absolutely not. And then on one particular morning she almost hesitated standing in front of the canvas before making a few strokes in black paint. And then she stopped. It's very hard to describe the feeling I had, but it was obvious to me that I was looking at something that had structure, even if I couldn't quite define it. It was Zen-like, intriguing, emotive: simple elements in perfect proportion. In short, it was very, very pleasing to the eye and it was the first painting of hers that begged the question 'I wonder what the artist was thinking?' Because it really felt like there was a deeper meaning behind those

minimal strokes. It was also the first artwork that I, as an objective viewer, would absolutely hang on my wall. And I found that idea particularly interesting: that I, the great minimalist, was contemplating buying a painting from a pig. If we could package that feeling, we really were in business and we'd be well on our way to creating a place for ourselves well outside the limited arena of 'animal art'.

Perhaps because the outcome was never predetermined, our process was dynamic, iterative and constantly evolving. Driven in equal parts by a need to keep Pigcasso engaged and a desire to push boundaries, I would place her paint pots at different spots around the canvas. Sometimes I would set down only one, other times two or three. We played, we had fun, there were no rules or regulations, no right or wrong, no historical influence from Michelangelo, Monet or Matisse to direct her style. It was pure, unlimited, innocent creativity; the kind of stuff you leave behind at school and spend the rest of your life trying to rediscover before realizing it's too late and signing up for a lifetime course with Eckhart Tolle instead. My apprentice was painting with wild abandon, at her own will and pace, and she was prolific. As more and more pieces of the puzzle fell

into place with each snout-stroke, I began to believe that we could sell some of her artworks as a way of sustaining the organization. I wanted to rescue a cow next, chickens after that, maybe a goat, definitely more pigs, but I knew that food and vet bills could add up fast. We needed a revenue stream other than benevolence. I had no idea what her paintings would, or could, be worth. A few cents, a few bucks: anything at all?

I consulted Harald. By now he was wondering if I'd lost my marbles, disappearing at the crack of dawn most days and spending more quality time with *das Schwein* than with him. Being an entrepreneur and an art collector in his own right, his advice was: 'Price them at whatever you want. If none sell after three months, double the price!' Hmm, a little outside the box, but yes, I liked it. Fortunately, the answer arrived without me having to think further about it. It was exactly four months since Independence Day. The barn was finally finished, and although I hadn't had time to rescue more animals, I had found a gap to design the bedroom loft I'd dreamed of and open up bookings. 'If you build it, they will come,' was my thinking. And they certainly did, from far and wide. Being in the heart

of a prime tourist destination meant that most guests were foreigners, drawn to the valley by the promise of fine wine and haute cuisine.

To keep the barn respectable, and to keep Project Pigcasso a secret until I'd worked out how to manage her career, I usually placed all the artworks in my house. But on this particular day, I'd left some paintings hanging to dry in the barn and forgotten to remove them before check-in. I got a message the following morning that the guests wanted to speak to me. They were a couple from New York, both attorneys. Was I going to be sued for something? Please God, tell me that Rosie hadn't eaten their suitcase! They started asking me questions about the sanctuary: how, why and when it came to be. What was my history and why this, here, now? And I thought, why all the questions? Then I realized that someone had obviously let the cat out the bag and told them about the pig in the corner pen. What now – were they planning to inspire a pig to do something in the Big Apple other than eat it, I wondered? As the conversation progressed, I realized that they were properly fascinated by the concept of a painting pig. These weren't eco-warriors or activists,

they were two well-heeled, highly educated, cosmopolitan professionals. And they'd taken a lot more than a passing interest in a story about a painting pig – or at the very least, it had grabbed their imagination firmly enough to delay their trip to the airport. What a win.

I told them all about the journey so far and described the process and ambition of what I could only describe as an 'artistic experiment that was still under construction'. They listened intently, and made no bones about the fact that they had fallen completely in love with Pigcasso. And then they pointed to a small canvas hanging on the wall. The paintings I'd left out were all monotone, mostly black, but the one that caught their eye was a simple composition: a flurry of red strokes spread across the canvas. Nothing special, but certainly one of a kind. 'How much?' they asked. Their question came as a surprise. How much for a Pigcasso? I'd never thought about that before. For once, I was speechless. I made a run for the bathroom to think about it while the couple packed up their bags. A few minutes later we were back in reception and I was trying to stop my head from spinning, acutely aware that this could be our very first sale and a pivotal moment in

Pigcasso's artistic career. 'Make an offer,' I said, surprising myself by how I'd channelled a Sotheby's dealer in a split second. They must have already discussed it, because their response was immediate: 'R7,000?' That was about $500, enough to sustain the operation for a full month. Deal! They looked as happy and as proud as if they had just welcomed their very first child into the world. This moment confirmed what I'd inherently known: that value is determined by a willing buyer, and we'd just proved that her art had value. More than that, it had the potential to hang in a New York City loft. Take that, Jackson Pollock!

Pigcasso was less than six months old and with one artwork sold in her lifetime, she'd equalled Van Gogh. And she still had years (and both ears) on her side. My mind took flight. I saw a pig flying across *The Starry Night*. Pigcasso was unique, Pigcasso had meaning, Pigcasso had weight. In a world of information overload, we had a rare opportunity to share a powerful story and message, and generate widespread awareness for the plight of farmed animals. Confronting the stifling attitudes of the old-school art fraternity would further fan the flames. Just as Picasso had made a radical departure from traditional

perspective with *Les Demoiselles d'Avignon*, Pigcasso could shake things up and challenge the status quo.

Hypocrisy around how we treat and eat animals flourishes in our social and cultural environments, which normalize cruelty, making it invisible and resistant to change. Pigcasso was the sum of all the inconvenient truths that animal lovers hated to discuss, and the discussion was long overdue. If her art continued to develop at its blooming pace, could she hog the limelight and ignite conversation? Who wouldn't watch videos of her painting, and who wouldn't want to support a pig, a sanctuary and art with a message? In an instant, a new goal appeared: to sell a Pigcasso for a million bucks. That would make people sit up and listen. She was a true original, with no competition, no rivals and no attitude: the ultimate rags-to-riches tale. What's more, she had the talent, the charm and the appetite to convert the most die-hard meat-eater into a marshmallow on the barbecue with one stroke of the brush. The idea consumed me, and in that moment, I believed she could become the heavyweight abstract expressionist of the moment. Pigcasso, my friends, could change the world. No, wait: Pigcasso *would* change the world.

7.
'Porktraits' & Patience

We were clearly making progress, but the realization was dawning that hitting the big time would take more than just abstract expressions from an animal. There is a surprisingly long history of animal-made art in the 20th century, and the zoological galleries of the world have featured works by dolphins, dogs, cats, parrots, horses, rhinos, elephants, turtles, sea lions and even a tamandua, which is a type of furry anteater, in case you were wondering. And there's an equally long history of academic mutterings on the subject,

with scientists, philosophers and animal behaviourists all having their say, and having sleepless nights about whether or not animal creations can, and should, be defined as art.

Think about Pollock's drips, a self-shredding Banksy, or (one of my favourites) Salvatore Garau's invisible sculpture *Io sono* (I am), which was auctioned off in 2021 and supposedly does not exist, but does exist in a vacuum and is therefore a bargain at €15,000. It even came with strict instructions attached to the certificate of authenticity, stipulating that the work must be displayed in a private house in a 1.5m cube of space devoid of any physical objects. Try and explain that to visiting aliens! The point is that we debate or evaluate the merit of these works from a distinctly human perspective, effectively marking our own homework. Perhaps a more valuable way of approaching animal art is to accept that it may exist with the express purpose of questioning and challenging the relationship between humans and animals in a way that helps to bridge the widening gap between us. Changing the paradigm in this way makes the whole concept of animal-made art infinitely more interesting, both to pursue and to debate, because it seems to fit into three distinct categories.

Firstly, there are works created by trained animals in captivity to do their art, including elephants that draw self-portraits. Despite the best attempts of the zookeepers and circus owners to claim there's some sort of 'behavioural enrichment' involved, it's hard not to dismiss these performances as being, at best, pure manifestations of a Pavlovian response and, at worst, blatant animal cruelty. Perhaps if the elephants drew different pictures each time, we'd have a different view, but they don't.

Secondly, there are examples going back to the 1950s and '60s of primates, and even a rabbit, creating paintings, apparently of free will. Most took place behind bars, in zoos, where the animals were reportedly given paintbrushes to introduce some novelty into their lives. I'd include sketching dolphins in this category. It's a nice enough idea, giving animals something to do that allows them to exercise their minds, instead of just their bodies. There's a theory that it allows them respite from repetitive habitual behaviour, but with little scientific proof to back it up, it seems to be another example of solving problems that shouldn't exist in the first place. The most famous of them all is a male chimpanzee called Congo. He was born

in 1954 in London Zoo and, when he was two years old, he was given a pencil and a piece of paper by the British zoologist and artist Desmond Morris. Congo drew a line. Then another, and another. And he didn't stop for the next eight years, moving mediums from graphite to paint and completing more than 400 works in his lifetime. It's widely reported that Picasso himself was a fan of the chimp's pictures, and hung one on his studio wall after receiving it as a gift.

Commentators at the time labelled Congo's work 'lyrical abstract impressionism' and Morris opined that Congo seemed to have a sense of intention and coherence in his paintings. It was hard to prove, though, as none of the works contained anything figurative, like a tree or a face; almost all of them featured radiating fans made up of thick strokes of colour. When that failed to convince, Morris would tell stories of how Congo would go into fits of rage if his brushes were taken away before he was done and, once a work was 'finished', he'd refuse to continue painting no matter what the incentive. For the record, it's a far cry from Pigcasso's routine. If she was ever interrupted while painting, or stopped by herself, she'd

just eat something. Why waste a single calorie whining when there's dining to be done? Congo's place in art history came only in 2005, decades after his death, when a set of three paintings was included in an auction that also featured works by Renoir and Warhol. As luck would have it, neither of the latter sold, but Congo's works were bought by an American collector called Howard Hong for an unexpected $25,000. Congo had set the bar for the most expensive animal-created artwork ever sold. (I tried to track down Hong, of course: as an ardent fan of abstract animalistic expressionism, how could he afford not to have a Pigcasso hanging in his hallway! He had unfortunately died in 2010.)

Still, the challenge of categorizing the artworks by Congo and the rest of his 'free will' colleagues continued to sit with me. Abstractionism, by definition, describes an artistic principle based on thoughts and ideas, not physical reality. As the artist, if you're unable to express those thoughts and ideas, it's hard to differentiate your intentional work from something random and meaningless. To understand the intent behind an abstract work, you have to be able to communicate on a relatively high intellectual level, which

is something that almost all animals have trouble doing. It would have been resolved easily if one of the animal artists had produced something compositionally definitive (or identifiable without having to squint). Until then, 'intent' would always be hard to prove. It had certainly never been done before. Given all of this, I was sure the cynics and the critics and the curators of Tate Modern would probably dismiss Pigcasso's art out of hand simply because it was not done by a member of *Homo sapiens*. It stank like prejudice, but I wasn't going to win *that* debate. I had something else in mind.

If there was one story in the annals of animal art that particularly resonated, it was that of *Et le soleil s'endormit sur l'Adriatique* by Joachim-Raphaël Boronali at the turn of the 20th century. A vivid flurry of reds and yellows and turquoise, Boronali's Adriatic sunset was cheekily labelled an 'excessivist' work and sold for 400 francs. Boronali, however, turned out to be a fictional name created by writer Roland Dorgelès, who had tied a paintbrush to the tail of a donkey called Lolo and 'assisted him' in making the painting. This appealed to my maverick sensibility, but I realized there

was also something deeper at play. This wasn't just a mischievous prank – it was more like a collaboration. 'Assisted' seemed like a third and distinct school of animal art. I needed to get more involved in Pigcasso's process. I realized that the way to stand out was for me to take a far more active role, influencing her compositions and enabling them to take on forms and figures beyond random strokes on the canvas, that would be unique and captivating to the human eye and mind. If we could incorporate a human perspective and merge our skills, it would challenge the critics to acknowledge that what we were creating couldn't be dismissed casually and denounced as 'animal folly', as had so often been the case. If I were to let Pigcasso paint for painting's sake, she would produce art, but we'd struggle to elevate ourselves above Congo. Her art would always be meaningful to those touched by it, but it might not be as powerful as it could be in a world that values human endeavours above all. Pigcasso and I had had many twists and turns on our journey so far, but this was a defining moment, and we never looked back.

Pigcasso would still be doing all the painting, but

I would add my artistic touch and influence from afar. And, crucially, I would add undeniable intent. This, I knew, could take the collaboration into uncharted waters. The line between human and pig would be blurred (aren't both of us animals, after all?). Where would the artist begin and the paintbrush end? Pig bristles were used in artists' brushes already. Just because my brush was, well, a tad heavier and had a mind of its own, it wasn't much different, was it? As a lover of philosophy, it was brain on.

There were two practical challenges to resolve. Firstly, I needed a second pair of hands, and with Claire overwhelmed by dogs in need, I turned to one of the house-cleaners on the property, Evelyn. She was young, proactive and well organized. She was someone you could rely on to get the job done with a smile, and I'd always liked her spirit and energy. She also seemed to love animals and was always taking scraps of food over to the barn and giving them to the pigs. So, having passed the required test for 'compassion and consideration for the things I love and value', Evelyn was ready to graduate. The second challenge concerned the process itself. At times, Pigcasso would paint a shape or a unique stroke that would be instantly lost

to her enthusiasm for more. If I could stop her in between strokes, based on what I saw emerging from her painting, I could steer the ship and prevent Pigcasso from sailing it in all directions. Using the clicker, I could teach her to drop the brush when she got to interesting places. We started to experiment.

As Pigcasso painted, I would watch from a distance. If I saw something interesting unfold, I would click. She dropped. She'd back away from the canvas, and while Evelyn gave her some more grub, I'd decide what colour or positioning should come next. And so it went. Gone were the long days of summerly strokes. Sometimes I'd click after a second, other times, I'd let her rock 'n' roll. It wasn't about how long she could paint for at any given stretch of time, but rather the quality and observance of the strokes that made all the difference. Precision was never the goal; it was impossible in any case. This was a highly creative process, and I could guide the brilliance of her brushstrokes only to a point. I couldn't force it. Just a shorter stroke in the right place at the right time and, *eureka*, an average painting could be transformed into a brilliant, and potentially valuable, piece of art. If I moved

the paint pot further to the right of the canvas, she'd focus her strokes in that area. If I turned the painting sideways or upside down, I could get her to paint in a whole new section of the canvas.

The most intriguing moments were those when she'd make incredible shapes all by herself – a heart, an initial, a number – and I would stop her, asking myself what more it needed. A red stroke to depict a mouth? I'd grab the red acrylic, position the pot in the right spot and make sure to stop her a second after she'd made that short 'smile'. On other occasions, the colours would depict the theme. For example, if Brexit was the topic of the day, I'd select red, white and blue, symbolic of the British flag. The fact that she had the letters *B*, *X*, *I* and *T* in the artwork was fluke, or pure and utter genius! It didn't always go according to plan, but when it did, it was amazing. Some people got it and could see what I saw; some didn't. In that case the title, written on the painting, was there to help.

I could see something in almost every artwork, but then again, show me a cloud and I'll show you a genie. Sometimes the paintings were a dance of colourful

strokes, some were straightforward, others complex and delightful in their own way. But when a painting hit the bullseye with a decisive subject, it was magical. I'd wake up every morning and walk over to the barn, wondering what trick she'd pull off, hoping that today was the day she'd write 'PIG' for the first time and we'd be able to call the BBC World News! I was also working with Pigcasso on a way to sign the artworks, a key component of every great artist. The solution was right there staring us in the face, or more accurately, on her snout. She learned quickly to dip her nose onto a shallow tray of ink, walk up to the canvas and 'kiss' it. Good luck, I thought, to any fraudsters who would one day try to fake a Pigcasso.

A perfect snowman with two eyes, a black butterfly, a self-portrait: they seemed too good to be true, and I knew sceptics would raise an eyebrow. I began to record her painting the artworks on my iPhone, showing that I had no hand in the painting. A finger on the clicker, yes, but never in the paint. Apart from changing orientation, the only time I ever touched the canvas was to trim the work at the end, name it and counter-sign it. Every artwork would be sold with a Certificate of Authenticity, citing a stamped

reproduction of her nose tip, along with the name of the artwork and my signature. With the pieces all in place, the i's dotted and the t's crossed, we had to get down to some serious work and build the catalogue.

8.
Penguins & Penny Drops

It wasn't all a Sunday afternoon on the island of La Grande Jatte. Impatient as ever, and focused on making every artwork something special, there were times when I was extremely frustrated at not being in complete control. Forget virtues here – patience was my villain, and Pigcasso decided to teach (or train) me otherwise. She had been enjoying the sanctuary menu for over a year by now, as her waistline proved. She'd always been a slow mover, but now that she was weighing in at almost 200kg, I got

the impression that she moved more slowly than usual when she knew I had an important meeting lined up after the session. She'd sometimes bulldoze herself into the veggie patch and destroy three months' growth of carrots before arriving at the canvas. Other times, we'd be on the verge of an iconic piece at the tip of her brush, with only a small dash of colour needed in the right place, and she'd walk right up to the canvas, give me a little wink of sorts and splash paint in the wrong spot. She drove me nuts. But we were family, and no matter what unfolded, the painting was always an original Pigcasso and, by definition, unique.

As we refined our process, the penny dropped: the more a human observer could relate to the subject matter in a Pigcasso artwork, the greater the connection between them and the artist, which was our main reason for doing all of this to begin with. The works represented a living, symbiotic, positive collaboration between woman and beast that couldn't be ignored; a new way to look at art and a new way to relate to a farm animal beyond the dead and disconnected. For a pig to paint is a feat in itself, but for a pig to paint something that almost everyone can identify without squinting is next level. Regardless of how much

I guide the process, the fact is that Pigcasso's artworks often have discernible form, figures that can be read in a human context, and none of it is contrived or learned. I didn't teach Pigcasso how to paint. I encouraged her to pick up a brush, so what we've established is a collaboration on equal terms: an understanding and respect for the process and each of our roles within it.

A great example of this is Pigcasso's *Penguin*. It's a miracle it was preserved because the moment happened so quickly. This is not unusual. As Pigcasso can only lift her head to a certain height, she always paints in landscape format. Split seconds separate a Jackson Pollock from a Jackson Bollocks. On this occasion, she did a few strokes in black on the page and it was only because of the unique angle on the left side that I paused her for a minute to investigate further. I turned the artwork around and bingo, a perfect penguin! More than that, it was uncannily familiar: a sophisticated clone of Pablo Picasso's *Le Pingouin*. The works began to flow, showcasing Pigcasso's intelligence and creativity, and the pressing point that pigs deserve to be treated better. And I was loving it all. It was such a novel project, so blue-sky, so rebellious, so

spontaneous. It nourished my creative soul, which for so long had been starved as I travelled the world, played golf and lived on sugar.

Creativity has hung on my family tree for as long as I can remember. Both my grandmothers were avid artists in their own right, and I had grown up surrounded by oils, acrylics and small easels. As a young kid, I vividly recall sitting with my grandmother in her modest apartment in Cape Town, painting Table Mountain and flower still lifes in watercolour. And, from an early age, my family nagged me to paint. 'God gave you a talent and you're wasting it!' My memories of junior school are coloured by powder paints, large rolls of cheap brown paper and Miss Black, who rallied me to keep my focus on the canvas while canvassing for animals at the same time. I also attended art classes in my free time and recall one particular exercise when we were tasked with painting a cat. When it was done, the cat's owner (aka humble servant) quietly made me an offer behind closed doors, and at nine years of age I'd sold my first painting. In high school, I excelled in the art practical exercises but failed miserably when it came to history and theory. While I had a soft spot for Van Gogh,

I'd never cared much for Rembrandt's biblical scenes or the fact that Michelangelo worked for nine consecutive Catholic pontiffs. I respected the Old Masters, but felt little connection with their work. It bored me, and the lack of interest was reflected in my rather unremarkable grades. Truth is, although art did offer a much-needed space of solitude and reflection when I lost Oscar, I generally found painting for painting's sake so damn boring. 'One day, when I'm old and can't do much other than sit, you'll find me on the mountain tops painting,' was my answer to my family. I wasn't inspired to sit around all day perched in front of a canvas, copying the cat or endless landscapes. I needed an underlying purpose and wanted to make a bigger impact. I had a burning desire to keep swimming against the tide, using my creative energy to guide the way.

Painting with Pigcasso was unlike anything I'd learned in art class. It was entirely devoid of rules and that meant we had to be agile in our thinking. I didn't want her getting bored, and decided it was time for a change of scenery. A few outings would keep her invigorated and a little exercise wouldn't do any harm. So we'd pack up the easel, the paints and the picnic and head off for scenic

getaways around the Cape. Getting Pigcasso in and out of the car was easy going when grapes were placed along her custom-built walkway attached to the back of the vehicle and she took the ride in her stride, always making sure that we had just enough manure to keep the valet service on their toes. My newly adopted dog Benny would join the trips and the two of them kind of got along. They were never going to be besties, but they respected each other for their strengths: Pigcasso had a clear weight advantage, Benny had the bite.

Pigcasso loved digging up the Cape's beaches, especially when the security patrols panicked but couldn't do anything about it. I mean, what could they do – hoofcuffs, anyone? She loved to explore the national parks, our favourite subject being Table Mountain. On almost every occasion, the police or officials would arrive, issue a ticket for bringing a pig to their park, and inevitably surrender their case when she started to paint. Not surprisingly, she attracted more than her fair share of attention. While no one would blink an eye at a bacon cheeseburger, a living, super-sized pig getting her artist on at the beach or chilling out in the back of a Mercedes-Benz Vito in peak-hour

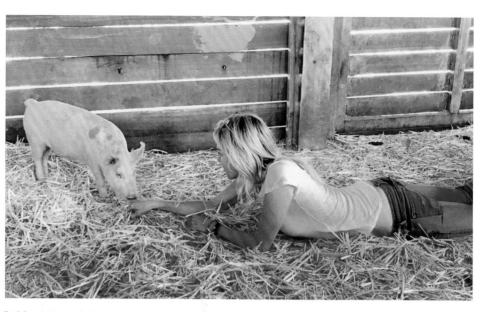

In May 2016, a piglet rescued from a factory farm found a new home at Farm Sanctuary SA near Cape Town. When the piglet was given a number of different items to play with, she showed particular interest in a paintbrush, earning herself the name Pigcasso.

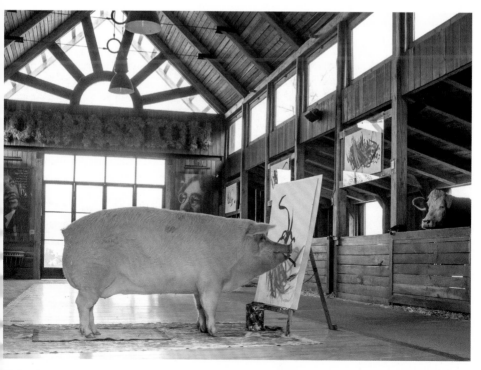

Today, Pigcasso weighs in at an estimated 400 kg (880 lb), making her probably the world's biggest artist.

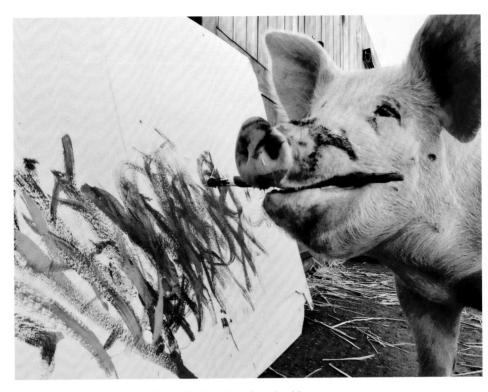

In the early days, Pigcasso used standard paintbrushes, the thin handles of which were bulked up with foam tape and cardboard. Before she was six months old, Pigcasso had sold her first painting.

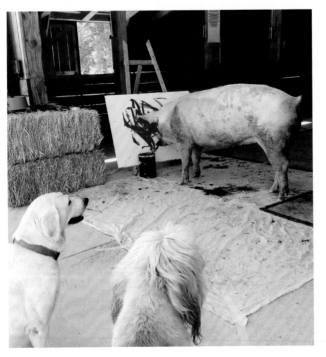

Now, Pigcasso uses custom brushes that are easy for her to pick up from a pot of paint and take to the canvas. Pigcasso's paintings help support the Oscars Arc Dog Adoption Centre, which has found homes for more than 4,000 shelter dogs – some of whom end up becoming part of the Farm Sanctuary family, where they get to watch Pigcasso at work.

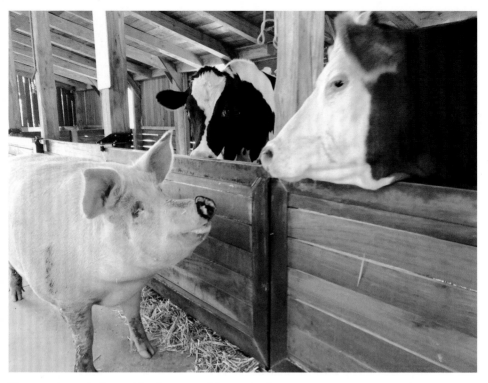

Pigcasso shares the barn with other rescued farm animals,
including cows, donkeys, goats and chickens.

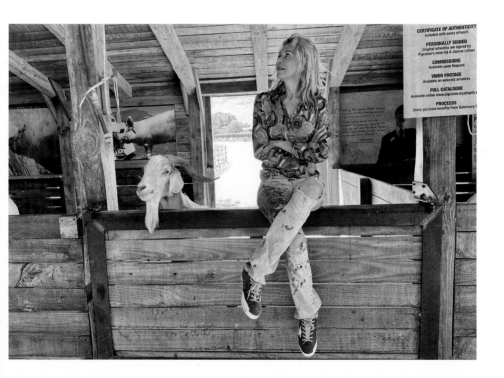

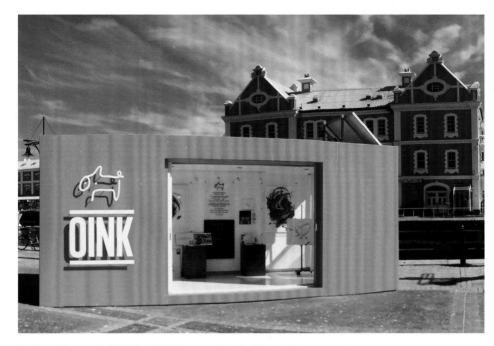

In 2018, Pigcasso's OINK! exhibition opened at the Victoria & Albert Waterfront in Cape Town, South Africa – the world's first-ever solo show of art painted by an animal.

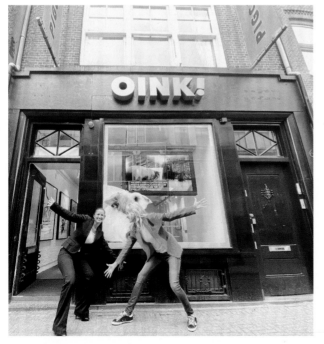

In September 2021, Pigcasso's work was shown in Europe for the first time, at a pop-up gallery in Amsterdam.

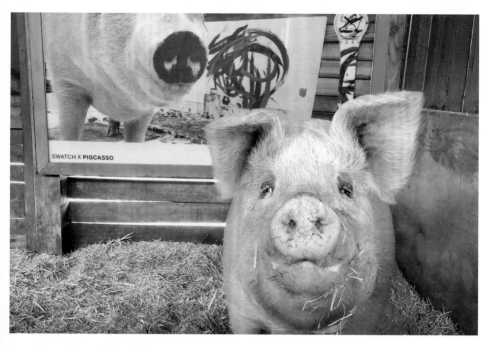

As well as making paintings, Pigcasso has also taken on a variety of commissions, from decorating a surfboard to designing a limited edition Swatch in 2019, which sold out in a matter of hours.

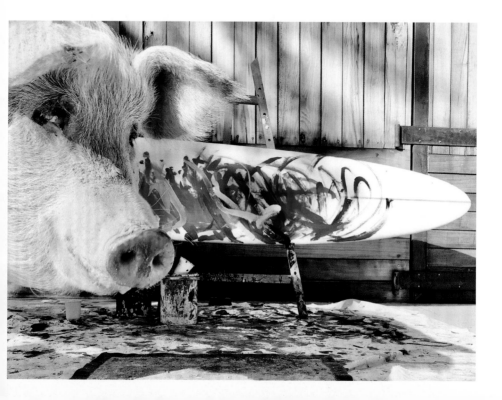

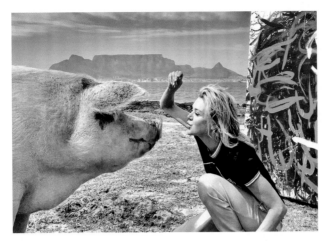

Painted in 2021 on a canvas measuring 160 x 260 cm, *Wild and Free* is Pigcasso's largest work and took weeks to complete. The colours were inspired by the seascapes of South Africa's Western Cape.

Wild and Free established Pigcasso as the biggest-selling non-human artist in history: within three days of the painting being posted on the website for a price of US $26,500, it was bought by a collector who already owned a few of Pigcasso's artworks. He wanted this one for his holiday home in South Africa, overlooking the Indian Ocean.

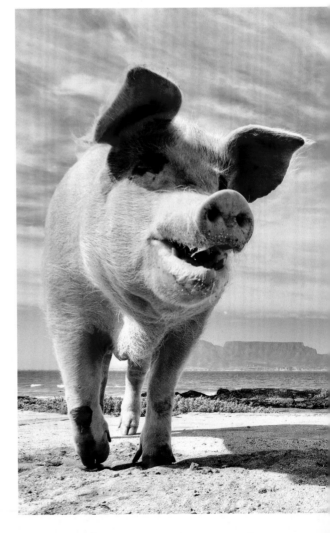

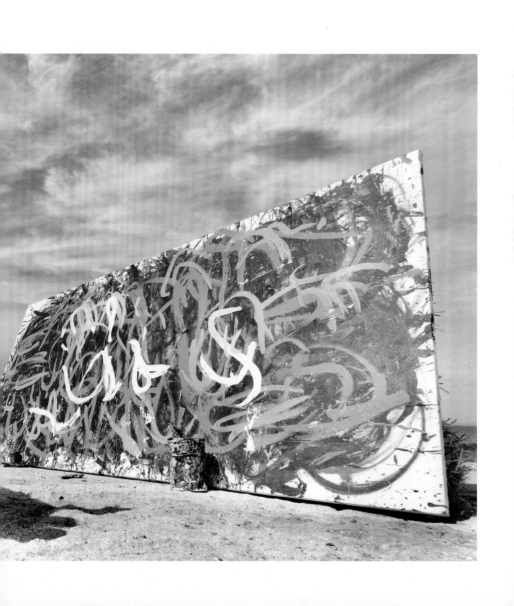

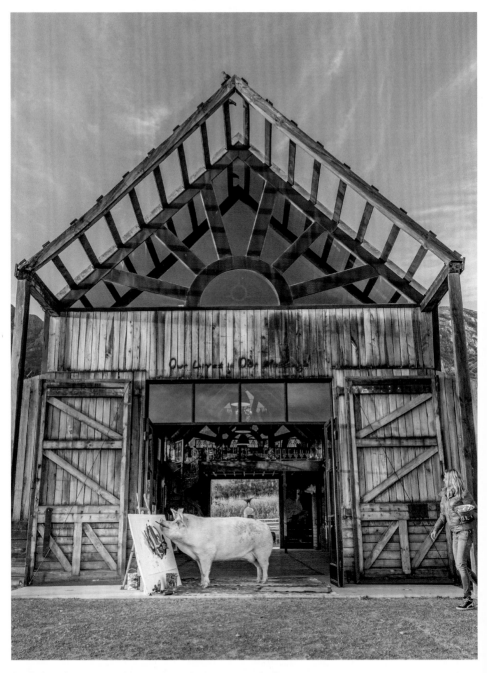

Spelled out in rusty metal letters above the entrance to the barn are the words 'Our lives is our message' – a reminder that the sanctuary is a little piece of paradise, compassion and empathy where farm animals can feel safe.

traffic was a little unexpected. The double-takes were priceless.

The only location that we exited hastily was the Bo-Kaap, right on the edge of the Cape Town CBD. It's an iconic, majority Muslim neighbourhood with multicoloured historic houses that make it an obligatory stop on any walking tour of the city. An Instagrammers' paradise, it's *the* place to pose and, even better, paint. Unless, as we found out, you're painting with a pig. We parked, set up and before we had a chance to begin, word had spread through the tight-knit community. The Vito was surrounded and I was faced with a mob threatening to 'kill the pig'. I stepped on the gas and we got the hell out.

When on location, Pigcasso would paint the scenic vistas, with me directing as best I could from a distance, swapping out paints and trying capture it all on video and camera. As creative director and pig PA, there wasn't any time to talk to the passing public, and that suited us just fine. This project was never about entertaining an audience. Of all the atrocities we inflict on animals, bullfighting and circuses – and any other act involving animals purely for entertainment – upset me the most. That people pay to

sit and watch these acts seems so primitive, so barbaric, so demeaning to both the animals involved and our own species. So when someone asked to watch Pigcasso at work, it would get my blood boiling. But I realized this was my own issue and I learned, over time, to wind my neck in and say, 'Not today, sorry.' There were also practical issues involved. We needed to make the most of these day trips. If we got sidetracked and Pigcasso got tired, I knew she might refuse to get back in the Vito. I slept on the beach once on the world tour with Oscar when I ran out of money, but I wasn't about to do it again with a half-ton roomie. So I always respected the first rule of talent management: protect your star from burn-out.

By the end of 2016, Pigcasso had settled in as Lady Muck, her spirits seemed high and we'd sold one painting. Getting to know her made me appreciate Winston Churchill's famous statement that 'Dogs look up to you, cats look down on you. Give me a pig! He looks you in the eye and treats you as an equal.' But while Pigcasso may well consider me her equal, unlike me she can't navigate the internet, and it was time for us to take the project up a notch.

All I'd done until then was post a few images online, one of which had found its way to a news agency that had followed Oscar and me around the world. They wanted to know more. I sent them more images, provided some background and went back to washing the paint off my clothes, cooking for the Queen and watching the paint dry. Past experience had taught me that if a story's compelling enough, it will develop a life of its own. Media exposure is all about seeing if the fish will bite. And when it came to Pigcasso, what we triggered was more like a feeding frenzy in a piranha pond.

9.
Becoming a Pig Deal

A fat, fabulous, painting pig from South Africa was the biggest news story of the year, or at least, that's what it felt like to us. We were inundated with calls, and there were journalists flying in from all over the place hoping for an audience with the star of the sty. The only paper that she couldn't crack, ironically, was the *Franschhoek Herald*, our local gazette, which had about 900 subscribers. Perhaps the message was too close to home, or maybe they just didn't get it. Franschhoek prided itself on fine wine, caviar

and the illusion of bona fide French flair, and the thought of a painting pork rillette overshadowing their public image was enough to make the French Huguenots who established the place turn in their collective graves.

But outside of our immediate neighbourhood, the story went viral. When it landed on Unilad, which at the time was one of the largest social video-sharing platforms on the web, Pigcasso got 10 million views in less than 9 hours. And that was just the start. Videos popped up all over the show, she made headlines around the world and her name was heard on all the leading networks, from ABC News and ZDF to Sky News and the BBC. In the US, she was featured on *Good Morning America,* and *Saturday Night Live* used her story to introduce a segment on the 'amusing' irony of loving animals and eating them. And on the other side of the pond, even the department store Selfridges & Co. wanted to put Pigcasso up on their in-store big screens.

In the middle of it all, I opened my laptop one morning to find an email from the *The Tonight Show Starring Jimmy Fallon* sitting in my inbox. They were astounded and intrigued, and would like to formally invite Pigcasso to appear at the Rockefeller Center studio in New York – and

what were the chances of her painting live on the show? Maybe it's just because I'm part of the 'Oprah generation', but I've always thought that the real measure of stardom is when the big talk shows start calling, and I was over the moon. We'd cracked the big time. Not that Pigcasso was ever going to get a visa for *The Tonight Show*, or fit onto a plane any time soon – let alone into a dressing room – but the invitation alone felt like our greatest hit so far.

And it wasn't just scribes and shutterbugs looking to get in on the action. A specialized brush maker wanted the honour of making Pigcasso some bespoke tools, but they obviously hadn't read the fine print: brushes made from the hair of animals bred in captivity? Ah, thanks, but no thanks. We also received a shipment of popcorn from a fan in New York. Gerry, the sender's pig, apparently had the hots for Pigcasso and knew the way to her heart was through her stomach! There were also some strange requests. An autograph collector in Kazakhstan wanted her signature, a German collector of fine objects wanted a few bristles of hair, and another wanted permission to duplicate a painting as a tattoo on his bicep. Copyright issues aside, that did seem a bit obsessive. The fan mail

included exotic photographs of nude snouts and a very specific request for a painting that was destined to be glued to the ceiling above the writer's bed. Things were starting to get a little bit weird around that barn.

What was next, I wondered? Was it time to get Pigcasso a bodyguard, a masseuse, a press agent? (Oh wait, all me.) Or a specialist art lawyer, in case we got hit by a lawsuit from Pablo's estate? What I did know for sure was that I needed to get her insured, which proved to be a lot more difficult than you'd imagine. Explaining the concept to an insurance broker would result in one of two outcomes: either the call was cut mid conversation, or I spent the whole day on the phone. They couldn't get their heads around the net worth of a painting pig: too large for an agricultural policy at 32 bucks a month that covered her spare ribs, but too small for the Charlize Theron plan that covers everything, including her talent. It was a hopeless exercise. Thanks for your interest . . . policy denied.

Then, in 2017, we got an interesting call. Nissan, as part of an advertising campaign to celebrate the sixtieth anniversary of their Skyline model, were looking for a new track design that would challenge their GT motorsport

world champion, Michael Krumm. The team in Japan wanted to know if Pigcasso could 'design' a test track, which would be interpreted from an actual painting. My pig, a racetrack designer? Sure, why not! Next she'd be racing in the Indy 500. One month later, three directors flew in from Tokyo for one day to shoot the scenes. No pressure. At 5am two trucks pulled up packed with all the latest camera equipment – tracks, reflectors, sound, staging, you name it. Charming, professional and polite, they even had a very realistic rubber snout to shoot the close-up scenes. Hollywood had arrived at my hog's doorstep, and best we get the makeup on.

Not quite understanding how Pigcasso preferred to work, they insisted she paint 'over there' or 'that side' or 'this side'. They pretty much wanted her to paint everywhere except in her own comfort zone. My nerves were shattered as I moved her from one place to another, praying that she would stay with the programme and cooperate. As it turned out, there was no need to stress. Pigcasso rose to the occasion and followed the director on cue. While I didn't really understand anything that they were saying for most of the day, the team left happy and

loaded up with souvenirs. Hay strands, paint droppings, loose brush bristles and hundreds of selfies with Pigcasso: off it all went back to Tokyo. For the ad itself (billed as 'The Wildest Circuit') the Nissan team extracted an insane, overlapping, higgledy-piggledy racetrack that they'd painted out on a massive parking lot. Mr Krumm manages to negotiate it rather well, and about halfway through the lap he's shown a video revealing who the real designer is, and can't help cracking a huge smile. It's just beautiful.

The next big break came when I received an email from the Swiss watchmaker Swatch. Would Pigcasso be interested in designing their 2019 Limited Edition? Heck, if she can do racetracks, what's a watch, right? They wanted an artwork to be the face of the brand, and commissioned her for a day. I figured if we could handle the pressure of shooting a commercial for a major international auto manufacturer, making a pop icon timepiece tick would be a cinch. We set up alongside the entrance of the barn. Above, carved in rusted steel is the line, 'Our lives is our message'. True to form, Pigcasso once again made history. I selected the pink and purple colours, placed the brushes in the pot, stepped aside and prayed. As the camera rolled,

she waddled out of her stall, strolled up to the canvas and looked at me as if to say, 'Watch this!' As Beethoven's Symphony no. 9 rang out, Pigcasso took the brush in her mouth, lifted it towards the canvas and started to paint.

It was done in a flash. She had painted the profile of the side of a pig's face, to perfection. It was extraordinary and beautiful. *The Flying Pig by Ms Pigcasso* Swatch sold out within hours of being released, and it remains one of most successful watches in the brand's history. We hadn't been told when the watch would be released. They chose the first day of the Chinese Year of the Pig and boy, did we know about it then. The media frenzy was bigger than ever: from CNN to the China Global Television Network, the story of a pig designing a watch hit headline news around the world. There was a sudden rush of orders for Pigcasso's artworks, too. From school teachers in Brisbane to media moguls in Mexico City, the demand was global and diverse. Everybody wanted a Pigcasso. This time around, though, I was almost expecting it. The Swatch collaboration, from a marketing perspective, was always a no-brainer. This ad campaign would get everyone talking. What fascinated most people was the fact that Swatch had reached out to

us and not the other way around. I took great pleasure in stating every time I was asked: 'Yes, indeed, Swatch called Pigcasso, and yes, this pig is extraordinary!'

The spin-off of the Swatch release lingered. A Russian artist threatened suicide because a pig had sold more art than he had in his lifetime; the curator of a museum with famous people's signatures begged for one of Pigcasso's nose-tips; and *America's Got Talent* invited Pigcasso on the show. In New York. No audition needed: she would be expedited straight to the second round. I pondered the prospect of a pig on a plane, in a taxi, backstage and on stage. I weighed up the awareness that would be created against the inescapable fact that we would be much like a circus act. The decision was soon made for me. Airlines didn't make allowances for pets larger than Great Danes, Pigcasso wouldn't fit through the main cabin door, and there was no way we'd accept a position in the hold.

On the back of all the coverage, though, sales were soaring. Some bought Pigcasso's art as an investment, seeing dollar signs in the long-term potential of an emerging artist. Others bought because they appreciated the message and wanted to support a noble cause. And

then there were people who just loved the art. For many, it was a combination. No matter the reason, the sanctuary's piggy bank was growing and we had proof of concept for a viable, sustainable business model. And, if the feedback we were getting from the public was anything to go by, people really were starting to pass on the pork.

When I was growing up, the American primatologist and conservationist Dian Fossey was one of my idols. She was famous for undertaking extensive studies of mountain gorillas in Rwanda from 1966 until her death in 1985. I was sweet 17 and captivated by the movie about her life, *Gorillas in the Mist,* in which Sigourney Weaver played her beautifully. It was an iconic movie of the time, telling the story of how she fought for gorillas, and ultimately died for them too. Although the crime was never solved, it's generally agreed that she was murdered by poachers who felt threatened by her fierce determination to protect the gorillas of the Virunga Mountains. I still cry when I think about her death, and how she must have felt when poachers slaughtered her favourite gorilla, Digit. It had taken her years to earn his trust and eventually be able to sit alongside him in the forests. Her grief was extreme.

Imagine, then, what went through my mind when I got an email from the office of the legendary English primatologist and anthropologist Dr Jane Goodall – she wanted to buy a painting. I refused to accept payment. Her work studying the social and familial interactions of wild chimpanzees in Tanzania stretched over six decades, and is unrivalled in commitment and scientific significance. She had also talked about the intelligence of pigs on many occasions, and was a strong advocate for a widespread shift to plant-based diets for the benefit of humanity and animals. Best of all, she did many of her talks with a little toy pig, named Piglet after Winnie-the-Pooh's friend, perched on the podium. This lady was an icon for animal rights *and* she was super cool. Being British and always in the news for all the right reasons, to me she was bigger than Buckingham Palace. Pigcasso and I dropped everything. Dr Goodall's painting wasn't next, it was 'now'. I chose a green palette to symbolize forest canopies, and Pigcasso went about her work. Once she had finished it with her nose-tip, I countersigned. We called it *Chimp Eden*, which was also the name of the first and only chimpanzee sanctuary in South Africa, established by the Jane Goodall

Institute in 2006. We sent it over to Tanzania, via the most expensive and complicated shipping route in the history of mankind, and it arrived a few weeks later.

In her letter of thanks, Dr Goodall spoke of her love for pigs. They were the very first animals she had habituated. She talked of how she befriended one particular pig called Grunter until he eventually came right up and ate out of her hand, and how good that felt. She ended the letter by thanking Pigcasso, seeking redemption on behalf of humans for what we do to pigs, and asked that I give Pigcasso an apple from her, in memory of Grunter. Of all the commissions we'd had, this one mattered most. To have a vote of confidence from someone I so deeply respected, and whose message aligned so perfectly with ours, was incredibly motivating. This wasn't about boasting or proving Pigcasso's credentials. It was a personal endorsement and it was priceless. Dr Goodall got it, and she knew that farmed animals needed any publicity they could get.

Inspired by Dr Goodall's interest, I decided to reach out to Sir David Attenborough and Brigitte Bardot, to whom Pigcasso had already given her snout of approval. I'd woken

up one morning thinking about celebrating animal rights champions, and had been telling Evelyn who Brigitte Bardot and David Attenborough were. When Pigcasso got up, she walked straight up to the canvas and wrote *DA*. Moments later, on a canvas that already had a backdrop of heavy black strokes, she walked up and painted what looked like a loop. I clicked her to stop. I moved the canvas a little, changed colours, and she walked up and proceeded to almost duplicate the first loop. I clicked. She stopped. I turned the canvas around. There it was, smack bang in the middle: two colourful *b*'s on a background of black swirls. OMG. I sourced the address of Sir David's private residence and had the complimentary painting flown in. As for Bardot, I knew where she lived in Saint-Tropez, having run past her beachfront cottage on a number of occasions. It wasn't too hard to spot if you were on the lookout: the handwritten signage reminding vehicles to slow down for the animals, a hand-painted ceramic dog bowl filled with water for passing dogs. I'd be knocking on her door with her 'BB' masterpiece on my next visit – if I ever found time to hit the South of France, that was.

All in all, Project Pigcasso was met with an unbelievably

positive response. Despite millions of views and insane media coverage, there were nonetheless two local 'activists' who went out of their way to point a finger at us. They conjured up fantasy stories, including one that suggested I didn't feed Pigcasso if she didn't paint. They also accused me of manipulating a poor pig to make money. It was a curious situation – why target a sanctuary that's accomplishing a rare feat: creating widespread awareness about the intelligence, creativity and intrinsic worth of pigs? What's to gain? I wondered why they didn't rather target one of the global fast-food megabrands, the ones who have proudly served their sad meals to billions of customers in burger-churches all over the free world (and beyond) for more than 60 years. If you're trying to make a point, surely that's a better place to start than a barn in the winelands? There are at least 100 such outlets in Cape Town alone, so the activists could have had a go at them rather and made a far bigger impact, if they actually cared. I didn't give it too much energy, but it did make me question the difference between people who actively make change happen and those who hide at home on their couches armed only with anger and insecurities, taking

out their frustrations on a keyboard. Personally, I didn't even own a couch, there was far too much to be done and I was grateful that I was driven by a deeper cause. Messages deleted. Sender blocked. 'Friends' unfriended. Social media does sometimes have its virtues.

All Pigcasso cared about, on the other hand, were the brushes, the menu, the mud, getting her beauty sleep and living her best life. Did she somehow know how famous she was becoming? Did she know that she was capturing the hearts and minds of millions of people, from financiers in Finland to farm folk in Kazakhstan? In the quietness of the barn that evening, with just a soft ruffling of the hay as she breathed slowly, I lay next to this large, gentle, sentient being and, for a moment, not a care in the world came between us. I placed my hand on her crusty coat and stroked her back. I contemplated how 'just a pig' was grabbing precious airtime on major networks around the globe, how she was giving farm animals a voice and starting conversations about what we do to them. On the wall above where we lay was a framed image of Babe, the piglet from the movie of the same name, who is raised by a Border Collie and herds sheep by speaking their language.

In the final scene, Babe becomes the star herder and crowd favourite, and Farmer Hoggett looks down to her in awe. I think I knew exactly how he felt. As the evening drew to a close, I reached over and gently whispered in Pigcasso's ear, 'That'll do, pig. That'll do.' She grunted softly, closed her eyes and drifted off.

10.
The Cow That Jumped
Over the Moo'tise

The sanctuary was a hive of activity: a non-stop stream of visitors, friends, TV crews and nosy locals. With our long-term sustainability secured and the dog adoption centre a work in progess, I was desperate to get back to rescuing animals in need. Both the Worldwatch Institute and the UN estimate that somewhere between 70 and 80 billion land animals are raised to be eaten every year. South Africa's slice of that pie, according to industry

organization Red Meat Research and Development SA, includes about 2.5 million cows and 6 million goats and sheep in a 12-month cycle.

On my radar, though, was an animal that many people are surprised to discover is indigenous to Africa: the modern-day descendant of the wild ass, aka the humble donkey. My natural love for donkeys and my experience in India put them top of the list. Having successfully herded dozens through a dust bowl surrounded by hooting tuk tuks, I was pretty confident that I could handle this mission solo, without needing Tinashe, a Mini or a pair of nonslip shoes. The plight of the donkey is peculiar: although an integral part of rural community life all over the world, it isn't traditionally seen as a farmed animal and yet its populations, both wild and domestic, are plummeting, particularly on the African continent. The reason for the decline in its numbers boils down, literally, to ejiao. This traditional Chinese medicine is made by boiling the skins of donkeys to extract the gelatine that supposedly treats anaemia, reproductive issues and insomnia. To satisfy the Chinese annual demand for ejiao (according to a 2019 report by Donkey Sanctuary UK) requires the hides of

nearly five million donkeys. Five million dead asses for a 'cure' with as much scientific evidence as rhino horn and pangolin powder.

It's hard to describe the scale of the threat posed to African wildlife by the world's newest superpower, but I honestly fear that it might be an extinction-level event for many species. Yes, the rest of the world has an equally appalling track record, but China does seem to carry a unique responsibility. Put simply, the trade isn't going to stop any time soon, and donkeys are just the latest in a long line of innocent victims. It's a thought that keeps me awake at night. Every time a species dies, we get one step closer to the biodiversity bubble bursting. It's the ultimate tipping point, if we aren't already there. And it's a one-way street.

I called a few local animal welfare organizations to investigate the possibility of rescuing a donkey from the rural settlements around the Western Cape, where they live mostly as beasts of burden, without proper care. I wanted to take in one who needed a break. Eventually I located a man called Carl in the Little Karoo, a farming region north-east of Cape Town, who had seen donkeys in the area that were being treated inhumanely. Harald

was back in Germany and had left his old Mercedes for safekeeping with me. Fearful of taking my Mini back into the battlefield, I decided to take his faithful old friend instead. Besides, he would never know.

Across the countryside I drove, Benny wagging his tail in the passenger seat to keep me company, with Neil Diamond's 'Cracklin' Rosie' blasting out the speakers. I found myself rehashing my thoughts when driving across those rolling hills. The sheep and cattle always seemed so peaceful out there. But then I'd look at the environment: the mountains and the area surrounding the wire fencing were abundant with fynbos (native natural shrubland) and rich diversity, while the farmlands were overgrazed and depleted of organic carbon stocks. Not even weeds would grow on these barren wastelands.

I thought of all those cows, and how life as they knew it would come to a violent, confusing end, mostly within two years of being born. One day rounded up, loaded onto a loud, overcrowded truck and then prodded into a slaughterhouse holding pen. Then wedged into a frame, with a bolt to the head (with luck, one that actually works), before being hung up by one leg to have its throat

cut. And if it's (un)lucky enough to be part of a halal or shechita ritual, holster the stun gun and just go straight for the jugular with a (hopefully) sharp knife. I wondered how people were able to block these thoughts when they casually picked packets of animal protein off the shelf, or asked a waiter to deliver it medium-rare with French fries. How can otherwise kind, intelligent consumers not give a second thought to the origins of meat and its turbulent journey to their table? For some, it's the ostrich effect, and it's understandable to a degree. I mean, who wants to see or hear or think of all that sad stuff, right?

Increasingly, particularly in more affluent societies, we're seeing a trend towards 'conscious consumerism': an increasing number of people who know enough (or feel enough) to want to change their carnivorous habits. So, while they still eat meat, they seek out free-range, grass-finished, drug-free meat in the hope that it will make a difference. And it will. All movements need early adopters to achieve tipping points. But there must also be a large percentage of society who do think about it, who do know at least some of the facts, and just don't care. As the fields blurred by, my head filled with thoughts of mass-market

apathy towards suffering, of unnecessary consumption, of extreme levels of fear and violence – much of it hidden behind factory walls, but some of it right out there in the open: just another day in the killing fields. At times like this, usually, my cell phone would ring and save my day, which is exactly what it did then. On this occasion, it was Carl.

I met him on the outskirts of a typical little Karoo town. He was local, knew the place inside out, and suggested I ride with him. That way he could explain how things worked as we drove around, dodging kids playing with makeshift bicycle wagons in the streets and trying not to run over the odd chicken scuffling around. You might call these neighbourhoods poor, but just like the rural folk in India, the people seemed fully engaged with life and immersed in the moment. On every corner, the kids would wave and shout out, 'Hallo, Tannie', the endearing Afrikaans greeting that translates literally as 'Hello, Auntie', but means so much more: 400 years of colonial history in just two words. It felt like we drove along every single back road in the Karoo that day, visiting towns both on and off the map, but we returned to my car a few hours later,

dust-covered and donkey-free. Carl blamed it on the fact that it was a Saturday and people weren't working. I was a bit relieved, too. It wasn't as if I wanted to find hundreds of skinny, overworked donkeys, half dead and dotted around the landscape. I thanked him for his time and went about doing some exploring on my own.

This trip took me in the opposite direction, through a few villages, and I slowly snooped around. And that's when I spotted him: a small calf chained to a pole in the backyard of a tin shack. I pulled up and took a closer look. He could only have been a few days old. Just a sack of bones, covered in crusted manure like a melted toffee that had dried in the cold. Innocent, helpless and emaciated, he was too weak to stand. Just out of reach lay a dented tin bowl, upside down. Aside from a few blades of grass trying to break through the hardened soil, the most noticeable feature of this tragic still-life was the rusted chain that kept him firmly in place. I was saddened, infuriated and immobilized. Now what? I was back in India in the Himalayas, but instead of a puppy ambling towards me, I had stumbled upon a cow. I knew exactly what this calf was and why he was there. By-products of the dairy industry, male calves have no

value and are discarded at birth, while the mother cows are continuously impregnated so that they give birth and produce milk. For humans.

In South Africa, the majority of these calves are either shot and treated as garbage or given away to the dairy staff, who will typically raise them for a few months until they have some meat on their bones. A small percentage become local veal, a non-descriptive word that hides the callousness of an industry hell-bent on finding a commercial use for these supposedly useless calves. In Western Europe – France, Italy and the Netherlands in particular – veal is still a big deal, and although veal crates (small cells designed to restrict movement and supposedly keep the meat as tender as possible) have been banned in the EU since 2007, the industry remains contentious. At worst, the streamlined industrial operations comprise vast production units where the animals are isolated in small kennels surrounded by a few square metres, crying out for their mothers, until they are finally slaughtered at 18 to 20 weeks old. These calves can be so crippled from confinement that they have to be helped into the truck or trailer on the way to the slaughter. At best, the living

conditions are slightly improved and the calves may get to suckle on an old cow that's been retired from the dairy herd. The US lags behind in terms of legislation (though certainly not in scale of production), and the crate system is still not outlawed in many states. The whole point of 'white' veal is to create pale and tender flesh; to achieve this, the calves are fed an unhealthy, low-iron diet of milk replacer made, ironically, from skim and dried milk, further by-products of the dairy industry. It's a real horror show. Ever since learning about veal while studying at university and pasting black-and-white watercolours of these calves in their pathetic crates all over campus, I had been haunted by it. It was unfathomable to me that intelligent animal-lovers could sit down in restaurants and support this cruelty.

I approached a neighbouring shack and asked an old lady who owned the calf. A few minutes later, a man arrived, half drunk and surprised by this unconventional visit. I did my usual introduction, asking him why he hadn't provided food for the calf. I knew it wasn't his fault. He was a small part of a big, sick system. How could we judge him if he simply didn't know better? We chatted for a while

and my suspicions proved true: he worked at a dairy and they'd 'gifted' him the calf. I explained that the calf was not going to make it and suggested that I take the creature away to save him the hassle. The man wasn't going to give up without a haggle and after a fair amount of deliberation, he agreed to let the calf go in exchange for some bread, beans, *pap* (maize porridge) and Coke. And I was left to figure out how to get this bag of bones into the back of the car. The calf was too weak to stand, but small enough for me to carry it for a second or two, catch a breath and start again. It took some time and a few laughs from passers-by, but eventually I got him to my car and placed him on the back seat.

So my new rescue didn't look much like a donkey – but he was a farmed animal in desperate need. I started the engine, smiled at the calf and stepped on the pedal. As we drove, the windows started frosting up: not from the cooler temperatures of the storm that was brewing, but from the heat of the cow pies that soon adorned the back seat. By the time we arrived home, it was dark, raining and freezing cold. I wondered what this poor animal would have done on such a night, and how many more creatures were out

there who hadn't been so lucky. I called over John, who had grown into the role of five-star farm caretaker brilliantly and knew exactly how to prep the guest bathroom with hay. The calf would need close observation, so I figured he was better off in my house than in the barn, and the underfloor heating in the bathroom was exactly what he needed. John and I carried the calf inside. I gave him some porridge and went off to take a much-needed shower. When I returned to check on the calf, he was nowhere to be found in the house, not even a dung trail to track his whereabouts. He had to be outside. There, in the middle of a freezing-cold night in the pouring rain, the calf stood firm in the back of the garden, on his four shaky legs. Chomping on long grass. He stayed out there all night, eating fresh grass for the first time in his life.

The calf lived in my house and, as the days went by, grew stronger. I'd walk him around the farm on a lead, with Benny close by. He would try to run and jump at times, collapsing and stumbling back up. It was a precious time, a whole new experience, and I cherished the opportunity to rescue this little fellow. I named him Baloo – the name just rang true in the moment and it rhymed with Route 62,

the road along which he'd been found. In time he was moved over to the barn, and he grew huge, fast. Despite all the fuss made in the swine department, Baloo quickly became the sanctuary favourite. He was the young giant, the naughty cow who would run up to anyone, his long, sandpaper-like tongue always ready to drool over a friendly hand that reached out to stroke his soft hairy hide and overgrown ears.

In time, a few more rescued cows arrived to keep him company. And I did manage to rescue two donkeys in the end: Nacho, a retired old cart 'horse', and Blommie, relocated from a local shelter. Broiler chickens were rescued too: featherless, lizard-like creatures, thanks to a life of solitary confinement. Goats and sheep as well, and even another pig. Or three. The sanctuary became an active rescue operation and schools, retirement homes and volunteers started to arrive. The compassion was real and the pennies continued to drop. All the animals got along famously, respecting each other's space and enjoying life. Compared to humans and their ongoing wars, murders, genocides and massacres, these animals made a mockery of our so-called superiority and higher capabilities. If we

knew how to treat animals, we might just figure out how to get along a little better with one another.

Over time, Baloo became my clear second favourite. I know it's not good parenting to have a hierarchy in the home, but I couldn't help it. While Pigcasso and I were collaborators on a joint mission and were bonded by the brush, Baloo was furry and friendly, and a bit more needy. More like a dog. When he saw me coming, even from a distance, he'd jump for joy, run up, sway his head and lick me from head to toe. It was more a body scrub with that tongue of his, but it was so endearing; he always made me melt inside. Baloo also found the painting process fascinating. He'd watch intently. So much so that I placed a pot and brush in his paddock at one stage, thinking he wanted to give it a try. He was happy to be a spectator, though, admission free.

As for Harald's faithful old Merc, it never fully recovered from that shower of fertilizer. Harald returned to Franschhoek shortly after Baloo left the guest house, and the trip home from the airport, surrounded with the residual sweet smell of cow dung, was the end of the road. He put the car on *Autotrader* that night, but for some reason

none of the interested parties ever put in an offer after going for a test drive. The farm manager eventually ended up with the car, thanked Baloo for it and was happy to cruise the valley with a pig-shaped air freshener permanently dangling from the rear-view mirror.

11.
Hog Wash or Goosebumps?

Pigcasso continued to paint the town pink. Even though I was primarily focused on getting the dog adoption centre open, I always made sure to squeeze in some time with her, the words of a certain Mr Denver ringing in my ears, reminding me that 'the moment at hand is the only thing we really own'. Life is fleeting, and we knew that my artistic love affair could end at any time. We had no idea how long Pigcasso could or would go on painting; we had no idea how long she would live. She was, after all, a 'production

unit' when we saved her, no doubt fed a dubious diet from the day she was born to ensure she'd grow unnaturally fast and large and achieve 'ideal' slaughter proportions as efficiently as possible. How many steroid cocktails, one wonders, does it take until the effects are irreversible?

The experts weren't much help. Having never had a painting pig as a patient before, our local veterinarian couldn't offer advice on her artistic future, but was able to confirm that Pigcasso, with luck, could live for up to 12 years. His biggest concern was what her quality of life would be at that stage. There were no guarantees that her legs would hold under all that unnatural weight and the reality was that Pigcasso would keep growing. I'd seen this first-hand in one of the other rescue pigs at the sanctuary, Piggy-Sue. At half Pigcasso's age and weight, she was already buckling onto her forearms to avoid the pain of carrying her weight on her twig-like legs. She was also half blind: a pathetic victim of a farming system that prioritizes profit above all else and is willing to manipulate the laws of nature in the process.

I determined to let Pigcasso keep painting for as long as she wanted to, and attempted to build up her portfolio

(and reduce her waistline), so that if she did decide to change occupation, retire or – heaven forbid – pass away, then her legacy and the sanctuary's sustainability would remain secure. I now had four cows on the range; more would inevitably arrive, and it was easy to forget that every cute one-day-old calf could live, and eat, for more than 30 years. And sure, being a goal-driven maniac, I did have certain targets: hang in the Louvre, exhibit at the Royal Academy of Arts, sell that million-buck painting, turn the whole world vegan. How hard could it be? With the longevity of the queen quarterback's fairytale career uncertain, however, there would be a new rule: no more reject canvases for Rosie to chew. We'd take our time and, just like the moment, make each painting count.

Visitors were always welcome at the sanctuary. It was clean, authentic and relaxed – anything but chichi. People were always curious about Pigcasso and the comments were fairly consistent. The first two were obvious: how big she was and how good the art was! That was the moment to burst their bubble and share the news that she was so big thanks to all the growth hormones she had been fed. It's a fact. As for the art being good, well, thank you! The

FAQs were fairly predictable too. Did Pigcasso know what she was doing when painting? Did she enjoy it? And my absolute least favourite: does Pigcasso know her name? At that point I'd usually reach over to her stall and call, 'Pigcasso!' so that they could see her eyes roll towards me as if to say, 'Shut up, I'm sleeping. Stop asking such stupid questions, woman!' I'd follow up by asking if they thought their kid would know what he or she was doing if they had a brush in their mouth. The defence rests, your honour.

Of course, just as Pigcasso was smart enough to know her name, she also knew that she was painting as opposed to, say, eating. Did she enjoy it? From the way she bobbed her head back and forth, up and down, you bet. There was never any reason to doubt that she got a kick out of the process. Put simply, if she didn't like it, she wouldn't do it in the first place. On the rare occasion that I allowed someone to watch Pigcasso paint, I knew what was coming. Between strokes, she would be given food. This gave me time to change colours and assess the painting. It was part of the sequence that we had developed over time. 'Ah, so she only paints when she gets food?' they'd say. 'But doesn't every artist paint for food?' I'd reply. The difference was that

Pigcasso didn't postpone her pleasure. This pig was living in the now, and thanks to a business model developed entirely around her needs, she never had to wait for a sale or a commission to find fodder in the trough.

These interactions were fascinating, and I began to understand on a deep level that we have an underlying belief that consciousness and emotional intelligence are exclusive to humans. It's a mainstream belief that can be traced back to the 17th century, led by thinkers like the French philosopher and mathematician René Descartes. He reasoned that consciousness relied on having an immaterial soul and a discernible mind: something that can be established through language, discussion, debate and philosophizing. Since animals were unable to do any of those things, there was no proof that they possessed a soul. As such, animals were no more than machines; a cuckoo is no different from a cuckoo clock. It ultimately led to him performing a public vivisection on his girlfriend's dog to prove his point, which is not only horrifying but might also explain why he never got married. If we believe that animals feel nothing, and that their lives have value only in physical form, then they are reduced to commodities. And

it's the start of a slippery slope, I think. Even the simplest of words we use provide the grounding clues. We often refer to animals as 'it', rather than 'he' or 'she', implying an unconscious piece of matter, some 'thing' that we can mistreat, with no level of accountability.

For those of us fortunate enough to work with animals every day, this couldn't be further from the truth. And if those animals are pigs, the argument for sentience almost seems obvious. The question I asked, which no one else seemed to think important, was this: assuming that Pigcasso did know she was painting, could there be some greater purpose at play? I'm not into astral travel, I don't consult crystal balls at midnight and I don't believe in ghosts or the afterlife. Yes, I did spend a few weeks at the Osho Meditation Resort in Pune, India, learning dynamic meditation and wearing a maroon robe; but it wasn't to become enlightened, it was to get to grips with my anger and frustration at the atrocities of the human race. But let me share a secret . . . in the absence of any other reasonable explanation, I have seriously found myself asking: what if Pigcasso is psychic?

Bear with me here. I have always believed in this

project. I backed it and gave it the time it needed because I understood its uniqueness and its potential to drive home important messages and sustain a meaningful organization. Paint with purpose. Beautiful! It was always going to be cool, but you also need to know that there have been moments in that barn that seriously freaked me out. Moments that left me speechless. Moments I might not believe had happened, had I not recorded them. When my mom turned 69, I called her up and asked what she wanted. We'd never been a family to make a big deal of birthdays, but she was having a dinner banquet to mark the occasion and I felt it was the right moment to get her *something*. But what? I certainly wasn't going to pitch up with a bouquet of flowers to wither and die after a few days of glory. Then out of nowhere, she said, 'I'd like a Pigcasso.'

There had been a second wave of fantastic PR, and Mum had received quite a few calls from friends asking about 'that pig'. But she'd never enthused about the idea of owning an artwork. Being a solid meat-eater, and one who preferred not to enter into debates at the weekly Sunday dinner at which my extended family would merrily consume half a cow, it was a topic best left unexplored.

So when she asked for a Pigcasso, I was surprised. Doubly so when she said she'd like two: one with multiple strokes of a mustard yellow, the other with olive green. Both to have a smear of black on top of the respective colours, and both signed.

The brief was clear enough, but it was midday, the party started at six, there was loads to do and I now had to fit in a masterclass at a time of day when the resident artist typically preferred to pass on the paints. I ran to the barn and grabbed the colours Mum wanted. There were only two pieces of paper left, which meant that if there was a balls-up for any reason, game over. I called out to Pigcasso and, thankfully, she rose up, walked to the canvas, picked up the brush and started to paint. A few minutes later she had completed and signed the two artworks. Each had the base colours as per my mother's wish, but it was the black stroke on top that stopped me in my tracks. Pigcasso had painted a perfect six on the first canvas, and a nine on the other. Goosebumps. Holy effing moly. Pigcasso had never painted a six or a nine before, until this particular day, at this poignant moment. Beam me up, Scottie, I think I've just lost my mind. When I shared the video at the

banquet that evening, it was the ultimate party-stopper: an impossible fluke. How had she known – how on earth?

On another occasion we were busy with a painting and it just wasn't working. She lifted the brush for a few seconds, did a short stroke and walked away, acting as if she had no interest at all, before returning to the canvas. A short dab there, another there. Frustrated, in a last-ditch effort to at least add complementary colours to a disjointed, nonsensical painting, I added some orange to the pot. She went on to do two or three abrupt, uncharacteristic strokes, and then called the morning quits. I sent the image to my mum to ask if I should give it to my uncle. He had always wanted a Pigcasso, but wasn't in a position to afford one and, with a bit of orange and blue and loopy-looking eyes, could it be a very obscure expression of him? My mum's reply landed in my inbox with just two words: 'Prince Harry!' It was the day that the famous TV interview between him, his wife Meghan and Oprah Winfrey had aired, and my mum was spot on. There, in clear view, were Harry's blue eyes, the orange hair, and that broad, boyish smile. I posted it on social media. It sold instantly to a Spanish collector for $3,000, and the British tabloid

press had a field day with the story. One paper ran a survey for readers to vote on whether they thought the painting looked like Prince Harry, and 68 per cent voted 'yes'. Pigcasso, in the moment, had painted the hot topic of the day, without any prompting from me.

I became almost nonchalant about the crazy coincidences, like the profile of a pig that Pigcasso painted for Swatch, and her daintily dotted snowman, or the W that appeared out of nowhere on the painting that Ed Westwick of *Gossip Girl* had commissioned. At times, it was as if I was dealing with an oversized pink ouija board. Once she painted a perfect four and I said to camera, 'Come on, Pigcasso, paint another four.' And she did. When *National Geographic* was considering a documentary about her and we set out to do a painting for them, she painted the letters N G. I kid you not. When they later declined based on budget constraints, we changed the name of the artwork to 'No Go'!

Then there was *The Angels*. Some new friends had really come to my rescue when I needed a helping hand (and a truck!) to move a few Pigcassos across borders in the EU. They'd gone out of their way simply because they

believed in my mission. I was wondering how I could possibly repay them when I got news they were expecting twins. An original painting from their favourite artist? Of course! With a boy and a girl on the cards, I presented Pigcasso with two tins. She began with a few blue strokes that looked like a bird from a portrait angle. I turned the canvas and she added pink on the bird's body. And then she painted two connected As. They were unmissable. Vinnie, my farm manager, who was watching close by, joked that we should tell the couple so they knew what to call their twins. I kept the painting a secret for a few weeks while we waited for the big day and, when it arrived, a message landed in my WhatsApp. The parents were thrilled to announce the birth of two healthy babies. And then the final line: 'Please join us in welcoming Anton and Anastasia to our world.'

When I tell these stories, I'm often asked if I have a favourite, because they're all quite amazing. But the answer's a definite 'yes'. We were busy with a range of works painted in the colours of the South African flag. Over a couple of sessions, we'd developed a few canvases in the base colours of blue, green and yellow. On this

final morning, it was a matter of adding red and, if the composition still needed a dash of focus, black. On one of the canvases, Pigcasso's first stroke of the day looked remarkably like a big red smile. John immediately turned to me and said, 'Imagine if she could just put two dots for the eyes.' I answered, 'Yeah, right, just imagine!' We both laughed, knowing that was simply impossible. I turned the artwork upside down and saw a red-backed elephant. 'Mmm, that could work,' I thought, and set it aside. As we swapped canvases and put the finishing touches to the remaining works, John asked if we were done with the tusker. I wasn't convinced. It needed something more – a stroke of black to define another leg for the elephant, perhaps? That would be relatively simple to achieve, and there was plenty of room for error. 'Let's do it,' I said. We loaded up the black bucket. Pigcasso didn't blink. She grabbed the brush, walked straight up to the painting, very deliberately placed two black dots above the red smile, then dropped the brush and looked at us as if to say, 'How about that, then?' I'm not sure which was bigger, the smile on our faces or the one on the canvas. Unbelievable. Did Pigcasso understand English? Or more pertinently, could

she speak Xhosa? Because there was only one appropriate name for such an iconic masterpiece: Madiba. I had always wondered when Pigcasso would pay tribute to Nelson Rolihlahla Mandela, and this was clearly it. What a morning.

The list goes on, and so does her uncanny ability to question the boundaries between serendipity and intent. Trust me, I am no animal whisperer or magician: it's all about this incredible animal. Maybe we are more connected that even I am aware; maybe she's operating in a reality that I, as a human, cannot understand. Tell me how a pig paints a six and a nine within five minutes on the one day of my entire life when those numbers have any meaning? Two paintings, two flukes, one massive coincidence? Go on, sceptics, find some Cartesian rehash to classify it all as hog wash. But then please explain the second, third, fourth and fifth times . . .

Yes, we know pigs are smart. There is abundant scientific proof of extremely high levels of 'cognitive complexity' and equally extensive research to indicate complex psychology in the case of *Sus domesticus*. Do the required reading and you'll find general acceptance of pigs being at least as smart

as a three-year-old human. But as someone who's been face-to-snout with the subject for a while, I can honestly say that's a bit unfair on pigs in general, and most certainly when it comes to Pigcasso. As is so often the case, it's the less tangible, immeasurable aspects of the relationship that are more interesting than lab results. Why does it sometimes feel as if someone or something is watching while we work on a piece? Are we being guided by destiny or divinity, or is it just the unfamiliar possibility that the pig might know more than me? Either way, living with, working with and experiencing Pigcasso has taught me many things that defy human explanation.

'We need another and a wiser and perhaps a more mystical concept of animals,' wrote the great American writer and naturalist Henry Beston in his book *The Outermost House* in 1928. 'We patronize them for their incompleteness, for their tragic fate of having taken form so far below ourselves. And therein we err, and greatly err. For the animal shall not be measured by man. In a world older and more complete than ours they move finished and complete, gifted with extensions of the senses we have lost or never attained, living by voices we shall never hear.'

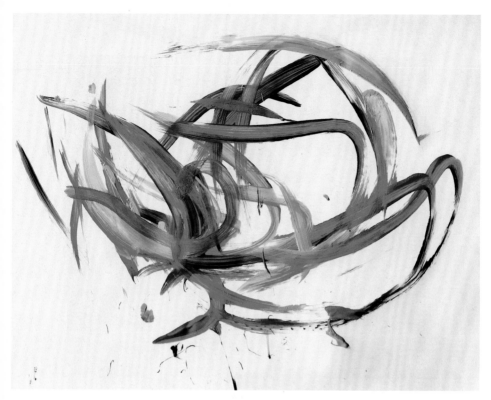

Chimp Eden, 2020
Acrylic on 300 gsm hot press paper
110 x 90 cm

Knowing that Dr Jane Goodall loves pigs, it was only fitting that
she should have her very own original Pigcasso. *Chimp Eden* is a
celebration of the chimpanzee sanctuary she established in the
Umhloti Nature Reserve in Mpumalanga, South Africa.

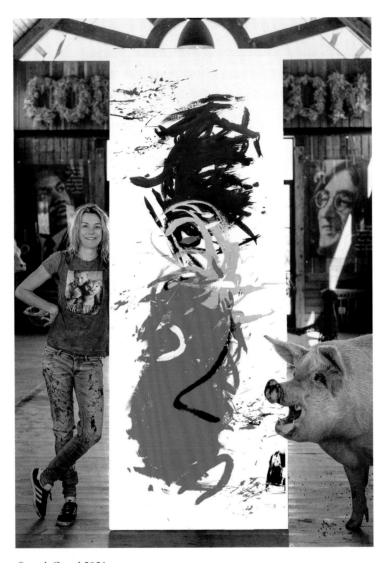

Queen's Guard, 2021
Acrylic on 300 gsm hot press paper
100cm x 280 cm

When I'm working with Pigcasso, a big part of the creative process
is developing a form or figure in the artwork to which the viewer can
easily relate. I selected the colours and kept moving the paint pot
below the long canvas to enable Pigcasso to make the strokes in the
right colours in order to create this iconic masterpiece.

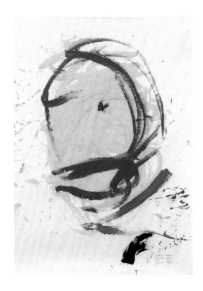

Frank Sinatra, 2019
Acrylic on 300 gsm
hot press paper
90 x 110 cm

Over time, Pigcasso's works
became more well-defined, with
increasingly recognizable forms
emerging, including famous
faces such as those of Frank
Sinatra, Freddie Mercury
and Prince Harry.

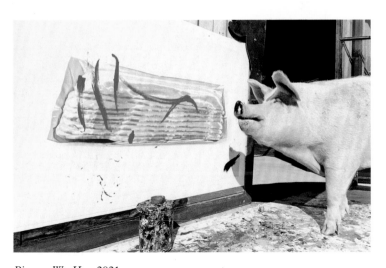

Pigcasso Was Here, 2021
Acrylic on photographic image
140 x 90 cm

It's amazing how many kids visit the sanctuary and, for the first time,
are able to make the connection between farm and food. One young
fan screwed up her eyes and said, 'But Pigcasso is so big and she's
an artist; bacon is small and it comes from a supermarket?' I had
the bacon image printed, dipped a brush in pink and waited to see
what would happen. In the blink of an eye, Pigcasso painted the side
profile of a pig's face smack bang in the centre of the bacon image.

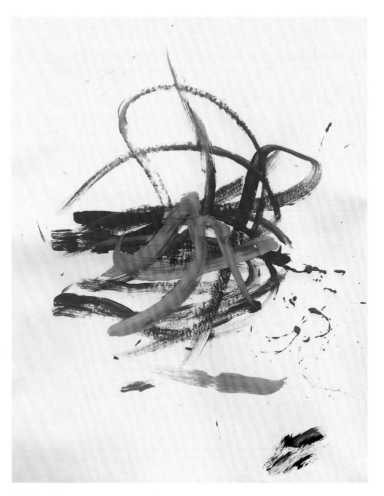

The Angels, 2021
Acrylic on 300 gsm hot press paper
85 x 105 cm

This painting was made for friends who were expecting twins. After
Pigcasso had made a few blue strokes that looked like a bird, I turned
the canvas and she added pink – two connected As. I didn't tell the
couple about the painting before the babies were born. When the day
came, the announcement ended with the words: 'Please join us in
welcoming Anton and Anastasia to our world.'

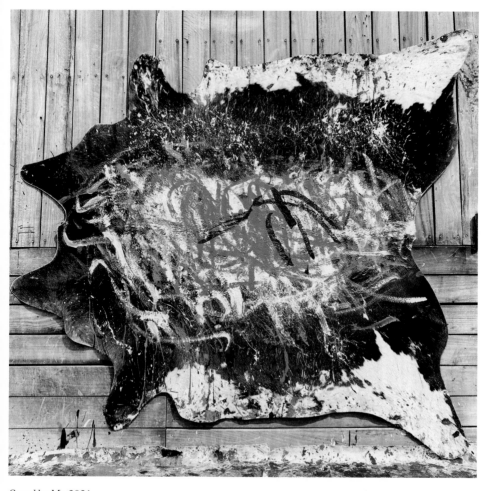

Stand by Me, 2021
Acrylic on 300 gsm cold press paper
95 x 120 cm

This piece was unashamedly contrived as a statement against
absurdity. I stapled the donated cowhide to the barn facade and
chose pink for Pigcasso, white to express an awakening and black to
symbolise violence. People walk over an animal hide as if it doesn't
exist. The experiment was to see whether people would walk over this
particular hide now that there was a 'piggy on its back'. I tested
it out; the general public stepped aside.

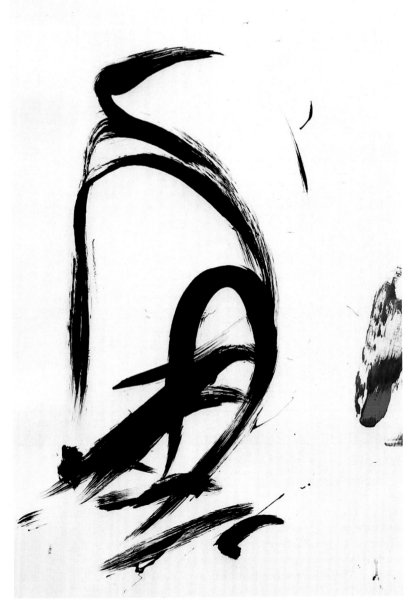

Penguin, 2019
Acrylic on 300 gsm hot press paper with
beetroot ink nose-tip signature
75 x 95 cm

Pablo Picasso did a series of strikingly simple animal sketches and
his *La Pingouin* always stuck with me. When I saw the unique stroke
that Pigcasso painted for this penguin's face, I turned the canvas into
portrait position and took a closer look. The rest is history.

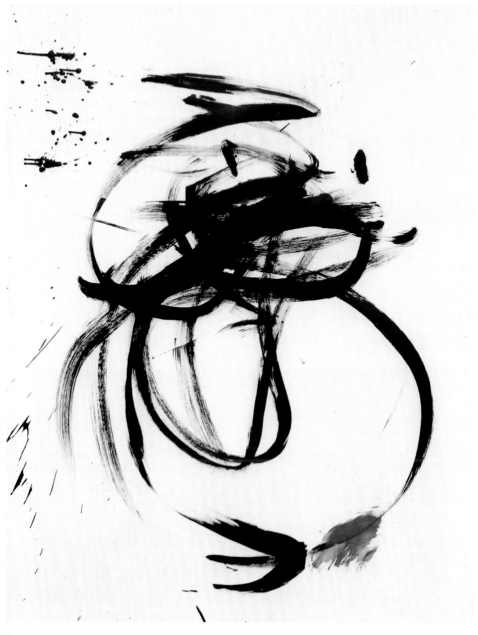

Snowman, 2020
Acrylic on 300 gsm cold press paper
90 x 116 cm

There's a reason why I video Pigcasso painting every single artwork:
who would believe a pig could paint this perfect snowman, with two
eyes in such perfect alignment? The right eye was the last stroke of
her brush: a final finishing touch to a work of art that is a highlight
of Pigcasso's monochrome catalogue.

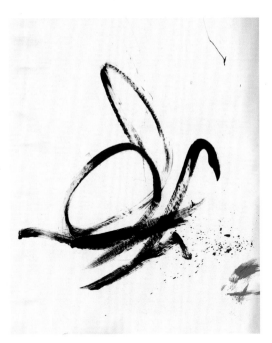

Butterfly, 2020
Acrylic on 300 gsm cold-press paper
90 x 120 cm

The butterfly effect is the idea that small things can have an impact on a much larger, complex system. No act is without consequences for others. Perfectly executed in a single landscape orientation, it was obvious what it was the moment Pigcasso dropped the brush. All I had to do was to turn the canvas for her to sign her approval.

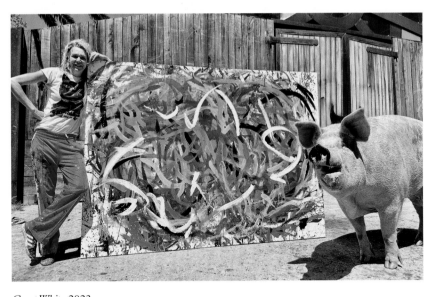

Great White, 2023
Acrylic on canvas
300 x 200 cm

By rotating the painting over and over again, I enabled Pigcasso to reach the entire surface of this oversized canvas. It took her weeks to build up the colourful background, but only one morning to add the bold white strokes that came together in a shark-like form.

12.
A Trojan Pig in Amsterdam

Staging the OINK! exhibition in Cape Town's V&A Waterfront in 2018 felt like a natural evolutionary step in Pigcasso's career, and the overwhelmingly positive response it garnered fired us up like never before. In the months that followed, her urge to paint seemed more intense than ever, and our collaboration produced increasingly vibrant and impactful results. When our contact at the V&A Waterfront extended an invitation to return in 2019, we didn't hesitate, and the show was met

with equal acclaim. Since the artist had put on 25kg in the interim, it was also met with equal amounts of spilled bubbly, squashed sneakers and flying chairs. Once again, though, the oohs and aahs and smiles and laughter were just icing on the cake. Achieving success in a mainstream of our own making was super-satisfying, but more importantly, it provided a proof-of-concept that no one could ignore.

The Pigcasso Project, in both its art and its activism, had developed authenticity and a meaningful legacy, irrespective of what happened next. The least I could do was to ensure we had all the necessary collateral in place, so I embarked on a major upgrade of the official website to align with the maturity and integrity of the project, add some gravitas and ensure we had our ducks, chickens and any other rescued fowls in a row when fate came knocking. Pigcasso had also developed an international fan base and we needed an appropriate, borderless, virtual home for them to visit, complete with an online gallery and a payment portal.

In the meantime, Pigcasso continued to paint, and the works became more and more well-defined, with

increasingly obvious shapes and recognizable forms emerging. Frank Sinatra, Freddie Mercury, Boris Johnson: even the 'non-creatives' could see the identities without a second guess. Well, most of the time. She continued to pop up in the global press, and we always knew when and where by the sudden rush of orders. And the barn continued to fill up. There were now four additional cows to keep Baloo company and a few hundred chickens bobbing up and down in the fields or sleeping on the pigs to keep warm. By this stage I was working 24/7 with my dog adoption initiative, which was starting to show meaningful results. By early 2020, when the COVID-19 lockdowns arrived, we had topped 3,000 adoptions, and Oscar's legacy was sealed. My track record with anything more than a short-term project wasn't exactly stellar up to this point, so it was amazing that the sanctuary and adoption centre had outlasted any tendency on my part to chop and change and move on to the next challenge. They were firmly established entities doing good, and I constantly thanked whatever spirit guides were responsible for helping me navigate the fine line between heaven and hell, success and failure.

When it came to Pigcasso, however, I was definitely in a Buzz Lightyear frame of mind: why aim for anything less than infinity and beyond? I felt an urge to get her into some high-and-mighty art fairs or exhibitions. If we could break in there, we could break in anywhere. It's up to you, New Pork, New Pork . . . or in our case, probably London Town, because my Uncle Alan had a personal connection with the Royal Academy of Arts, and in this world, who you know is worth a thousand bananas. Surely they'd be open to a bit of swine art beyond what was being served on the opening-night canapé platters? There was the Frieze London art fair too, which seemed to have an appetite for the contemporary and controversial.

If just one of these institutions had the balls to feature us, it would make for the biggest mud bath ever. I knew it had to be pitched right. As the project had evolved, so had my realization that a painting pig may be enough to enthral the public, but would not win over the formal art world as easily. I shifted perspective and, grudgingly, put myself first, relegating Pigcasso to the role of being my unique, oversized brush. No matter how many superlatives I threw at the pitch and how many

heart-strings I tugged at, I always knew it was going to be a very hard sell. We were, after all, entering a world in which Vincent van Gogh sold only a fistful of work before he died. But being South African, I thought also of Vladimir Tretchikoff. He was born in Siberia and died in South Africa in 2006. In the 1960s, he exhibited at places like Harrods in London and had hundreds of thousands of people viewing his work. Back in South Africa, thanks to a generous mix of prints, originals and limited editions, everyone from students to the stinking rich could proudly hang a 'Tretchi' on their walls.

But he was blackballed from by formal art scene. Throughout his career, the local art mafia saw him as something of an overly commercial nonentity. Sour grapes, maybe? Who knows? Either way, in 2011, five years after his death, his work was finally exhibited at the Iziko South African National Gallery in Cape Town and *Tretchikoff: The People's Painter* smashed every attendance record in the history of that venerable institution. These stories abound, and there are many, many more voyages of despair and frustration in the world of art than there are of satisfaction and delight. But I was determined that

even if our journey did end in a cul-de-sac, I'd never die wondering what might have happened if I'd tried a little bit harder to knock down the doors and break through to the other side.

Much has been written and discussed about the contradictory and complex web of relationships that exists between artists, high-profile curators, collectors, auctioneers, museum trustees and corporate sponsors. But the topic that always catches my attention is the ongoing complicity between the art and money markets. Nathaniel Kahn's eye-opening 2018 documentary, *The Price of Everything*, clearly showed how manipulated the art world is, and how much art sells for all sorts of reasons other than the art itself.

In this murky world, the difference between 'why?' and 'why not?' could be as simple as finding the right art powerhouse (or powerperson) at the right time in the right mood. And although I can't speak for Pigcasso, I certainly wasn't a virgin when it came to taking advantage of a situation. Success in the contemporary art world, quite often, is that fickle and random. If Pigcasso could catch a lucky break, she could hang in the greatest galleries on

earth: a Trojan pig, subversively carrying our message far and wide. I imagined Big Agriculture running for cover, confronted with a different kind of Bay of Pigs crisis; a groundswell of enlightened consumers turning 'Got Milk?' from a catchphrase into a criticism. A revolution song, and music to my ears.

It became crystal clear, rather quickly, that the barriers to entry to the high-end art shows, the Artissimas, Art Basels and Biennales, were designed along similar lines to Fort Knox. I wrote them all and, to their credit, I did at least receive courteous, personalized replies. But they all said the same thing: we needed to be represented by a gallerist before we could be considered, and no, they wouldn't be refunding the $500 application fee even if we were an NPO. Talk about a conundrum. You can't get into the shows if you aren't represented by a gallery, and the galleries aren't brave enough to represent anyone from outside the ropes. A pig? Yeah, pull the other one. Our last flickering of hope lay with Uncle Alan. Although Jewish and religiously inclined to avoid pork, he was a big believer in Pigcasso. Never one to mince words, he would have told me without blinking if he thought her art was banal,

derivative or downright awful. Instead, he was fascinated, and had often told me that her works were priced 'too damn cheap'. He had even purchased a few, always giving double the price as a kind gesture of support towards the sanctuary and our beastly convictions.

His stamp of approval was a real feather in our cap. My uncle is a successful businessman and an avid art collector with a direct line to the Royal Academy. Their Summer Exhibition is the largest annual open-submission show in the world – and has been since 1768. They also put on world-class exhibitions of art from every corner of the globe, welcoming hordes of art-lovers to their galleries each year. It's the kind of place that no doubt has an equal number of written and unwritten rules, so having Alan kindly reach out on our behalf was like sliding a foot in door. I held my breath. Er, sorry chaps, but no. Apparently Queen & co. weren't ready for an African pig to become the prince of Piccadilly.

And then it happened. Not quite out of nowhere, but definitely out of left field, we got a big, fat 'Ja, natuurlijk!' from the Amsterdam International Art Fair. They were 'delighted' to have us take part in their fifth edition,

scheduled for August 2022 and due to take place in the beautiful Beurs van Berlage building in the historic city centre. Whoo-friggin'-hoo! This particular art fair is organized by a collective known as GAA, the Global Art Agency, who have been building up a series of shows for the past decade that now includes Barcelona, Shanghai, Tokyo, Miami and Oxford. After all the soul-searching we'd been through, it was fitting that we would finally find acceptance in the most open-minded city in Europe.

I was everything all at once: astounded, elated, relieved, stoked, you name it. It put a fire in my belly like you can't believe. While the pop-up in Cape Town had proved a point, this latest development drove it home. If the doors won't open for you, learn to pick the locks. But it also made me think: if the capital of the kingdom of the Netherlands, the city of canals, was willing to open its arms to us, why wait for August 2022? What about a dry run? Maybe it was a bit mad to consider jumping the gun and opening a pop-up prior to the International Art Fair. I mean, partial lockdowns, limited tourism, a sanitizer thunderstorm – jeez, even the *Mona Lisa* was wearing a mask. But there was something exciting about getting going despite the status

quo. I also had a vague connection to The Hague. Bear with the history lesson here, folks. The city of Cape Town was ground zero for the colonization of South Africa from the moment Bartolomeu Dias and Vasco da Gama, looking for a sea route to the Far East, did Portugal proud by rounding the Cape in the late 1400s. But it was the Dutch who really got stuck in: built forts, created harbours, planted vines and trod all over the indigenous people of the region, the Khoisan, setting the scene for a future of extreme highs and lows, depending on which side of the castle walls you happened to be born. A few hundred years and many wars later, any South African child who grew up in a racially segregated school in the early 1980s was guaranteed to know more about Dutch colonial commander Jan van Riebeeck than Nelson Mandela, whether they liked it or not. The date of 6 April 1652 – when Riebeeck and his crew, on board the notorious ship *Dromedaris,* arrived at the Cape of Good Hope – was etched in our minds in a such a way that it would never be forgotten. Irrespective of their home language, everyone was forced to study Afrikaans, an offshoot of ye olde *Nederlandse* tongue. If you speak Afrikaans to a Dutch-speaking person, Flemish

in particular, they will smile and tell you it sounds like a child trying to learn their language. So for anyone who passed Afrikaans at school, or has any genetic link to the Dutch, hanging out in Holland feels remarkably familiar.

By now it should be clear that I've always considered *carpe diem* to be a direct order rather than a suggestion. Patience has never been one of my virtues, and while I'd followed Buddhism and ushered the Osho Meditation Resort into my heart for a few weeks, I seriously struggled to sit under a Bodhi tree for longer than a minute. With an inner voice that continually reminds me that the path to inspiration and enlightenment is not necessarily paved with boredom, I have become quite used to my impulsive side leading the way.

A young assistant, Caylee, had also recently joined my one-woman show, and I needed to keep her flame ablaze, beyond the daily filing, art logging and social media posts. Welcome to the trenches, young lady! She could do the run-around on the framing, price displays, check my spelling and ride shotgun. And then there was the sanctuary assistant, Evelyn. The thought of giving her the opportunity to venture beyond Franschhoek, spread

her wings and see the world for the first time moved me to tears.

If you've ever played golf, you'll know there are times you stand over a putt and everything feels right. Make that perfect. It sounds crazy, but you can 'see' the ball going into the hole and before you take the putter back, you absolutely know you're going to make it. This was one of those moments. The pop-up had heart. Opportunity wasn't just knocking on our barn door, it was hammering. And I loved the idea of rolling out our own red carpet in the artistic heart of the Netherlands. There was one teensy-weensy little issue: the plan made absolutely no financial sense. What. So. Ever. But it made so much sense on every other level that, to be honest, it was worth the risk. And if worst came to worst, we could write it off to marketing and promotions and butter up the tax man! Without further ado, I started Googling available short-term rental space near the Rijksmuseum. If this pig was going to make a big noise, the least we could do was make sure that Vermeer, Rembrandt and the rest of the Dutch Masters heard it.

Before I knew it, the deal was sealed. Deposits were paid and agreements made with the casual staff who'd

(wo)man the gallery for three months. I felt a surge of energy: this was a moment that needed to be grabbed, and I was the only one who could do it. It was the perfect time to concentrate on something I'd kept putting on the back burner: a catalogue, an artistic archive, a record of our journey so far. But it was also our vision. There were artworks that Pigcasso had made over the years that I linked to the cause: industrialized agriculture, climate change, animal welfare, animal intelligence. Wherever we were headed, this catalogue would have an enduring message for the past and future of the Pigcasso brand. I'd call it *OINK! A Collaboration to Connect and Inspire a Kinder, More Sustainable World.*

The first step was to put on my curator's cap and round up the best artworks; a combination of form, colour, content and style that aligned with the message. I wanted pieces that challenged our relationship with our food and our love for animals; that forced us to stop for a minute and think about every link in the food chain. And as I began to file specific works for the catalogue, I was astonished at how naturally it flowed, as if the paintings themselves were making all the decisions and telling their own stories.

As the narrative informed the catalogue design, everything fell into place. It was effortless. The gods were nodding in approval. Whatever else happened, and whatever form it would take, this book, this catalogue, this would be Pigcasso's ultimate legacy.

13.
Game, Set & Match

OINK! Gallery opened in Nieuwe Spiegelstraat in the fall of 2021. Pulling off our first pop-up on foreign soil was a feat in itself, but what made it such an adrenaline rush was that I really didn't know much about where we were going. I'd only been to Amsterdam once before, briefly, with my best friend. In the middle of the whirlwind European leg of our global tour, I'd spent three hours photographing Oscar perched in a bicycle basket alongside a picture-postcard canal, in the golden morning light. By the time the sun had

set, we'd done the same in Belgium, before falling asleep late in the night in Paris. The Netherlands really was a foreign land. No friends; no contacts; no long-lost cousin van Riebeecks or van Anythings. What I did have was the same pioneering spirit I'd always had, and I convinced myself that the blank canvas was a blessing, not a curse. We were going to make the best of it, South African style!

I rounded up the troops: Caylee, Evelyn and my cousin Bianca. Bianca had already overseen OINK! at the V&A Waterfront, so she knew the rules of engagement, and would ensure there was no ham in the sandwich in any way. Cool, calm, charming and more classic Aubrey Hepburn than contemporary-chic, she also had friends in both low and high places, which is a real asset when you're breaking new ground. Besides, with all those musty vintage clothing stores in the hood, there was no way she could resist helping out. In fact, she insisted on it, and helped with all the admin stuff which she knew would drive me to drink. She was also frugal. I could hand her the credit card and it wouldn't catch alight on the flight or be cut in half on arrival. We'd be booked in toilet-class, we'd carry all the overweight baggage on our shoulders, we'd catch a train

instead of an Uber and we'd 'stretch our legs' by walking from the station to the hostel. Whatever thrifty ways there were to bikini-wax the budget, she'd be on it, even if it meant dorm rooms with shared beds. But hey, we wouldn't have time to sleep in any case: the red lights were flashing and it was time to party.

The team united in the mission. While high-street stores hired professional (and expensive) shop fitters to recreate their space, there we were: four South African women and a guy (Bianca had found a friend) decked out in black-bag overalls. We painted the walls, mopped the floors, hung artworks that weighed more than Pigcasso and climbed up three-storey buildings (at night) to hang OINK! banners. Okay, when I say 'we', I should probably clarify: the team might hang me out to dry if I claimed to have got anywhere near as down and dirty as they did.

Truth be told, while they were covered in paint from head to toe in Nieuwe Spiegelstraat, this little piggie was on her way back to Cape Town to sort out some last-minute logistics. Getting 32 framed artworks through South African customs – 'art of pig for pop-up gallery in Amsterdam' – and airlifted to Europe had proved to be

something of a military exercise. It would have been easier trying to get Pigcasso herself out the country. Cheaper, too. And we'd ended up with one last piece, *The Queen's Guard*, sitting waiting to be collected at the framers and somehow transported to Europe just in time for opening night. I did the maths, and for roughly half the shipment cost of the 3m-long masterpiece, I could fly back, grab a few physio sessions, kiss Pigcasso, check the painting in as excess luggage and have a legitimate excuse for avoiding shifts as a construction assistant at the gallery.

The grand opening was grand indeed: pink popcorn, pig-shaped candies and a generous supply of the first-ever vintage of Pigcasso Black and Rosé wines. It was a new project that had more to do with Harald's passion than mine, but I'd wholeheartedly supported the process. After all, the grapes grew on the Sanctuary grounds and were Pigcasso's favourite palate cleanser, so it was nothing short of a miracle that there was still enough fruit left to fill a few barrels after she'd broken loose into the vineyard on a number of occasions.

It was a full house of movers and groovers, cool arty types and a smattering of South Africans looking for

a taste of home, or perhaps a free meal and a glass of something delicious and recognizable. Bianca got behind the DJ station and introduced me for the official opening, and I ran up to the hay-stacked podium. Nervous, but not enough to lose the moment, I welcomed everyone and gave them a full rundown on the how, why and what behind all things Pigcasso. I can't remember exactly what I said but I know it ended with a climactic toast to the artist. The rest of the evening was surrendered to the dance floor, loud conversations, a roomful of smiles and laughter, plenty of pats on the back and some intense negotiation on a couple of the artworks. As we locked up around midnight, I thanked my team and slowly walked back to my hotel. The calmness of the canals washed over me and I breathed in the silence of the night, broken only by the occasional muffled conversation from a late-night bar. I felt so honoured and so grateful for this fleeting, fabulous moment. What a marker in time for the project, for the movement, for all things bright and beautiful.

When you have a long and exciting build-up to big events, it's often a bit of a downer when everything's done and dusted, no matter how successful. Not this time. There

was no hint of an anti-climax, just a flood of gratitude to replace the daily task list that had been so all-consuming in the months leading up to the opening. How lucky I was to be setting a course through unchartered waters. Four centuries after passing ships introduced European pigs to the tip of Africa, one of them had found its way back home: a creative voyage for the ages, sailing on an overpopulated ocean through a storm of misguided ideology and aimless human ambition. What a privilege to be part of the crew.

We broke even on the show. But I knew full well that the real value lay in the ripple effect of Pigcasso doing a belly flop into the global art pool. We had turned 'visible' from an adjective into a verb. Despite lockdowns, limited footfall and competing on the most exclusive art and antique street in the city (and popping up alongside impressive galleries that supposedly boasted original Picassos), there was only one place where a crowd regularly gathered for those three weeks in mid-September, and it was outside number 61 – OINK! Pedestrians and bicyclists, even DHL delivery vehicles ground to a halt at the window and gaped open-mouthed at the big screen we'd set up showing footage of Pigcasso doing her thing. At midnight,

we'd have party-goers, late-night dog walkers and young people in various stages of inebriation gathering on the pavement. It was a seriously happening spot. At least, it was until some local residents complained about the ongoing noise. It was the kind of disruption that filled my rebellious soul with sweet satisfaction. Pigcasso was there: the 3m-high image of her bod on a flag banner, flapping in the breeze alongside the building. Yeah, Rijks, this pig has arrived! Heck, they could probably even see her from the International Space Station.

The Amsterdam adventure opened up all sorts of new ideas and possibilities, but I had never lost sight of my initial ambitious goal: to sell a Pigcasso for a million bucks, or at the very least beat Congo the chimp's $25,000 record for the most expensive painting sold by a non-human artist. I remember smiling, almost laughing, at the thought. Preposterous? Perhaps. But in my head, the conversation was quite different: 'Imagine *when* it happens. What a statement!' And with every thought, every dream, every brushstroke and every exhibition, the goal inched ever closer. I had never forgotten that moment when Pigcasso had sold her first artwork in the barn and I had started to

believe that she could sell, *would* sell, and could sell well. So I shifted focus onto the Mother of All Paintings.

Technically Congo had set the record with a set of three artworks, but who's counting? Until this point, I hadn't scoped out the basics: what would a painting by a pig need to set a new benchmark? It would have to be unique. Tick. According to accepted rules, it had to be colourful and large. Fine. But what if we made it larger than life? That would be another record in itself. Most of all, the piece would need the X-factor. No, wait, make that P-factor! It had to be impressive, impactful, mind blowing. *The Creation of Adam* in the Sistine Chapel, this time by a pig: connecting the plight of farm animals to humanity's hand with a god-like trotter and hanging somewhere fabulous for all the world to see. Philosophical musings aside, I knew all that was needed was intent on my side and trust in the artist. In golfing terms, this was no time to obsess over the yardage – we had to 'grip it and rip it'. So I ordered the canvas and got to work.

From the outset, I saw a sea of blue hues. Add a complementary twist of orange and some purple undertones and the palette was complete: a blur of old

Monet, a dab of new Poons and a hint of Bacon. The pots were in place, the canvas was positioned at the back of the barn and all I could do was wait for the artist to arrive. Pigcasso walked towards the canvas, lifted the brush and began to paint, oblivious to the significance of the moment. She painted and painted. The camera battery died. Recharge. Repeat. Paint, watch paint dry, recharge, eat, sleep, paint some more. Repeat. All we needed was a regular supply of pasta, peaches and peanuts. With each passing day, it felt like we were getting closer and closer to something truly special. We got lost in the process. Layers upon layers: a level of intensity we'd never reached before. Then, finally, after weeks on end, we stood in front of the canvas one morning and it felt like the clouds had parted. The work was done. An extraordinary effort. All she had to do was sign it in Miami pink.

Wild and Free was logged, authenticated, photographed and ready for posting on our new online gallery, with the price set at $26,500. In South African funny money, that was close to R400,000; about what you'd pay for a new Toyota Corolla so you could look like everyone else on the road. On one shoulder, a little voice asked, 'Will people

think we've lost the plot?' And on the other, a louder voice said, 'Who cares, we've got nothing to lose!' Fortune favours the bold, right? Even if it never sold, the fact that a pig could have a work of art valued well beyond people's perception of what any pig was worth made a statement in itself. Heck, if it didn't sell, I'd put the Harald principle into play and double the price. I knew we were on the brink of a history-making moment, whether the world was ready for it or not. My heart raced. I closed my eyes and hit 'Post'.

Twenty-four hours passed by. Slowly. I was feeling decidedly edgy. Somewhere in the distance, the voice of reason was now whispering something like, 'Look what you've done. You've gone and scared everyone off! Half of that amount would have kept the feed bags full for many moons!' Which was absolutely true, but at the same time irrelevant. There were still plenty of beautiful, regularly priced paintings available in the catalogue, so it wasn't as if we were suddenly pricing ourselves out of the market. All we were doing was conducting an experiment in unknown waters, and by definition there were no rules. So how about you just shut up, little miss full-feed-bags!

If the listed price was ahead of its time, so what? Worst

case scenario, if *Wild and Free* just sat there for eternity, one day in the future, some art student could use it as the peg on which to hang a final-year thesis about the relationship between art, price and perceived value. If it didn't, the upside was just too delicious to ignore. Imagine all the animals that would live to see another day thanks to funded rescues and a substantial life-line that would ensure their bags were overflowing, not just full. I went to bed that night feeling quite resolved, mildly conflicted and quietly confident. Just another regular day at the Farm Sanctuary, then.

And then it happened. Almost exactly three days to the hour from when we went live, an email popped into my inbox. Or perhaps that should be, THE email. It was from Peter E., a German collector who already owned a few of Pigcasso's works. An avid fan, he had always appreciated our artistic tango and been fascinated by the way we'd redefined the relationship between woman and animal. He'd seen the painting; he *loved* the painting; he wanted the painting. And he wanted the bank account details. It was for his new holiday home in South Africa, which was situated on a cliff overlooking the big blue Indian Ocean.

I couldn't have imagined a more perfect home for the piece of art that would assure Pigcasso her place in the history books. I swelled with pride. She had firmly established herself as the biggest selling non-human artist in history and proved to the world that pigs, if given half a chance, really can fly.

Our story is constantly evolving, and will continue to do so long after Pigcasso has gone to her bottomless feeding trough in the sky, but this moment felt like a major championship victory. News of the sale leaked and we starting getting requests for interviews in an entirely different way from before. This time around, the BBC and their pals seemed to realize it's wasn't just a 'fun and quirky' project or a curious headline to fill the front page. It was a rebel yell; a fist in the face of our limited views. One that does something unavoidably awkward, elevating a farm animal from that dead banger sitting alongside the sunny-side-down fried egg, into something inescapably beautiful.

I'm not sure if we'd reached some sort of critical mass, but it certainly felt that way. The paint had hardly dried on *Wild and Free* when I got an email from Rafael Nadal's

PA. They'd been made aware of Pigcasso's artwork *RAFA* and, well, there was some empty wall space at the Rafa Nadal Academy in Mallorca, and would Pigcasso oblige? Seriously? I'd been a tennis fan all my life, and one of my ultimate sports highlights was being at Roland-Garros when Nadal won his tenth French Open title. I had stayed glued to my seat long after the final serve, when the carpets had been rolled up and the crowds had dispersed, watching him charm the reporters and camera crews. Okay, so he's never made a stand against his country's tradition of bull fighting and, unlike Novak Djokovic, he isn't exactly plant-based, but he's still Rafa, and that particular painting was destined for centre court the moment Pigcasso painted two black horns in the first few seconds of picking up the brush. All I had to do was pause her, change the orientation to a standing (not sleeping) bull, and add the Spanish colours below. Olé! It had always been one of my favourite pieces, and I knew at the time exactly where I hoped it would land up. Within 48 hours of the email, *RAFA* was en route to Spain. Game. Set. Match.

When a story, a dream and a concept align and develop in just the way you hoped, it's easy to take it all for granted.

Things go your way – it's how it is. But one day I know I will step back, take a look from a distance and wonder, 'Did I really paint with a pig? Will I ever find a way to express in words how grateful I am to have had her in my life? Was our work really so admired and desired that we could fund a farm sanctuary with the sale proceeds? Did we really sell a million-buck painting?' None of us knows where we're headed on our little ball of basalt with its molten metal heart. The future remains an ambition. But if the story of one little pig from a global factory-farmed litter of billions making it out and becoming the greatest non-human artist in history doesn't inspire us to aim a little higher, think a little deeper and care a little bit more about our life and our planet, then what will? Maybe an original Pigcasso hanging out in your living room. Click here to buy . . .

14.
Banksy, Bananas & Bacon Bits

I know we touched on it earlier, but it's worth revisiting: what is art? It's a great question, and one that's been batted about since Aristotle and Plato first made thinking fashionable more than 2,000 years ago. It's satisfying to know that Pigcasso and I have been part of this ongoing conversation. More than that, I believe we have the potential to add an entirely new dimension to it.

The wise people at the Oxford English Dictionary define art as 'the expression or application of human

creative skill and imagination, typically in a visual form such as painting or sculpture, producing works to be appreciated primarily for their beauty or emotional power'. Seems reasonable enough. But crucially, it all hinges on the word *human*, so where exactly does Pigcasso fit in? I'm guessing that the intention of making art exclusively the domain of *Homo sapiens* is to ensure that intention itself is a core requirement. So, according to this definition, an animal doing something without intent can't be art – but an animal doing exactly the same thing as a result of human intent must surely qualify. Pigcasso could be seen as my paintbrush, expressing my intent on canvas through her free will, with my spontaneous guidance from a distance. Pigcasso's art could therefore be seen as my art – but at what point would it become hers, and still be regarded as art? If you're even a moderate follower of speciesism, exceptionalism, the Kantian concept of personhood or any other belief system that suggests there are distinct human characteristics that elevate our moral status above other creatures, it's an uncomfortable discussion. But that's the whole point. In my experience, you only start to appreciate beauty and emotion when you are pushed

out of your comfort zone. That's precisely why, from the different artistic movements, periods and schools to the artists, the purists and the piss-takers, the history of art has been such a wild and exhilarating ride. And when it comes to confronting established norms, in a contemporary context, Pigcasso is in great company.

Consider, if you will, the outstanding (or should that be upstanding?) contribution of Marcel Duchamp. Back in 1917, he received a porcelain urinal from a female friend who had purchased it in a plumbing store and signed it 'R. Mutt', the male pseudonym she had adopted. Duchamp declared the object a work of art, titled it *Fountain* and submitted the 'sculpture' to the Society of Independent Artists. By placing an everyday article in a context where its commonplace significance disappeared under a new title and point of view, Duchamp shifted the focus of artistic expression from physical craft to intellectual interpretation and gave birth to the genre of 'ready-made art'.

At least, that's one version of the story. It turns out there are quite a few versions, including one that details how Duchamp, together with friends, went to J. L. Mott Iron Works in New York City one afternoon and bought

a urinal. He took it home, flipped it over and signed it 'R. Mutt'. For Duchamp, submitting it to the society under the pseudonym (a society he co-founded, it's worth noting) wasn't to create debate around the artistic merit of *Fountain*, but rather to explore whether the society was willing to allow any old artist the right to make this interpretation. Regardless, the work quickly reached dizzying heights of controversy in the art world. The society, exercising its rights (and perhaps its duty), declined to exhibit the piece in its supposedly 'open' exhibition, prompting Duchamp to resign from the board in protest, on the grounds that all work was to be accepted and put on show as long as the artist paid the fee. You have to sympathize with the society; after all, a different decision may have resulted in every pay-toilet in Manhattan being considered a Dadaist masterpiece.

As for *Fountain*, proof of its existence remains in a photograph by Alfred Stieglitz. The original was lost, and the prevailing view is that Stieglitz threw it out after photographing it. But many of the replicas that Duchamp was commissioned to make in the following years feature in the most important art collections in the

world. What is clear is that Duchamp dented the creative universe by suggesting that conventional standards and norms should be criticized; that art should provoke; that it can piss you off, and you can piss on it. He literally created art that takes the piss! In more academic terms, he introduced a conceptual layer to art that moved it away from formalism and accepted norms and advanced the avant-garde agenda of modernist thinking. He also forced everyone to hold their noses, look down at their human inadequacies and ask the question: is this art? All Pigcasso is doing is following Monsieur Duchamp into the *pissoir*.

That displaced urinal inspired all kinds of artists to break the chain and tear down the city walls. And the 'rot' hasn't stopped – in some cases, quite literally. Consider Italian artist Maurizio Cattelan, for example, who bought a banana from a local Miami supermarket, duct-taped it to the wall at the Art Basel Miami Beach in 2019, called it *Comedian* and sold it for . . . drumroll . . . $120,000. And before anyone slipped on the peel, he sold a second and third edition of the work: different bananas, same fate. While it's true that he's more often called a prankster than an artist,

Cattelan strongly defended the idea that *Comedian* is not merely a bad joke. He argued that an enormous amount of consideration had been given to every single aspect, from the angle of the fruit to the texture of the tape, and that he'd been working on it for about a year, prototyping various incarnations – from resin to metal casts – before coming to the conclusion that, as reported in an *Artnet* article, 'the banana is supposed to be a banana'.

He wouldn't speak to the work's meaning (no surprise there) other than saying that he thought a banana could be 'a good contribution'. Of course, copies spread all over social media, but Cattelan wasn't concerned, stating that without his certificate of authenticity it would revert to being just a banana. And here's the rub: it was securing a buyer for the piece that completed the artwork. Had it not sold, it may well have rotted away and been forgotten. In an interview with *pagesix.com*, the Miami couple who bought one of the bananas acknowledged the artwork's 'blatant absurdity' and the fact that *Comedian* was nothing more than an 'otherwise inexpensive and perishable piece of produce and a couple inches of duct tape'. While conceding that the banana itself would have to be replaced

if and when they decided to loan the piece out to a museum, they figured it would become part of art history and was worth the price. Really? What sort of precedent does this set? They bought little more than a certified idea. Or have we entered a new age of vegan art? How long will it be before the whole of aisle five at Walmart, between bottled water and frozen pizza, gets knocked down as a priceless installation?

For me, the ultimate 'answer' is obvious: when art is Duchampian in nature, the ridiculousness of the whole thing is what it's about. It aligns with the famous Warhol misquote: 'Art is whatever you can get away with.' Well, I'm not sure. I think that art is whatever you are able to convince others to let you get away with. In other words, it's about context. That's why Banksy is a ray of sunshine. It's hard to imagine that someone who started out in a street graffiti gang in Bristol (by definition, a 'criminal') could find himself, 20 years later, pulling off the infamous self-shredding *Girl with Balloon* stunt at Sotheby's – and getting paid a million quid for doing it. When he 'donated' *Game Changer* to the NHS in the middle of the COVID-19 lockdown in the UK, presumably intending

they would auction it to raise funds, it became the highest priced Banksy ever sold, fetching £16.8 million. Although I'm sure he's enjoying not worrying about the price of a can of spray paint anymore, I can't help feeling that he sleeps soundly knowing he's achieved something far greater than fortune. From his first stencilled rat to being a global superstar, Banksy has forced the art world to ask very hard questions centred around disruption, criminality, institutional legitimacy and the establishment itself. He's invented a new game that the old rules don't cover . . . which brings us back to Pigcasso.

If art has evolved to the point where absurdity carries the same weight (and price tag) as intent, and meaning and concept are level pegging with physical form, then why on earth shouldn't the Tate Modern showcase a painting by a pig? What we think of Pigcasso's art is irrelevant and, believe me, she doesn't give a damn what we think of her talent. What matters is that she stands there on all fours challenging us to look past her personal hygiene habits and see her as a statement: a symbol that defines the extraordinary times in which we live, where a pinned plantain makes headline news and our coughing,

spluttering planet gets little more than a mention in the letters to the editor.

More than ever right now we, as a species, find ourselves in a curious place. For the first time, perhaps, since we learned to split the atom, we are looking at our collective self in the mirror and asking some hard questions: about our species, our way of being and our impact on the planet we call home. And although it's a mechanism that can easily be hijacked for the wrong reasons, it's no wonder that a 'populist' narrative underpins much of what's happening globally on the socio-political front. At the risk of sounding reductive, we really do need to start believing that we're all in this together. And to do that, we need to open things up to the widest possible audience. Democratization is the name of the game.

In some spheres of life, this process of opening doors is more obvious than others. Just look how the global sports field has become a political soapbox in the 21st century. Just look at what's happened on the fairways of the world since Tiger Woods won the US Masters in 1997 (the first of his 15 career major titles) and dragged golf from its Royal & Ancient clubhouse into a brave new world. We all

cheer it on and take collective credit for being part of the movement, because we're followers and fans. But I can't help feeling that sport, like Karl Marx's religion, is an opiate of the people. Put differently, doesn't all of it seem a little easy, like an OxyContin prescription? Like we're being given an instant solution, possibly even absolution, without having to think for ourselves? Art offers an entirely different high.

Even at its most banal (or bananal), art is designed to provoke thought, light fires, start conversations. It leads you to your own conclusions. And unlike the country clubs and elite athlete environment, there's no reason why it can't be a fully level playing field. To quote Warhol (this time correctly), 'I don't think art should be only for the select few. I think it should be for the mass of the American people.' Of course, I'm biased, but it seems there's a huge opportunity here for the great museums and institutions of the world to embrace Pigcasso as a prime example of art's ability to define the times. Who knows, it might even spark an interest in art for a new generation. For the Louvre, it could be a moment of redemption for having Frans Hals' portrait of Descartes in their permanent collection. It was

Descartes, remember, who argued that animals lacked language, intelligence or soul. So let's get the ball rolling by finding some wall space in the Grande Galerie alongside that portrait for *Pigcasso Was Here*.

The inspiration behind this painting was a can of soup. Not any old can, but rather *Campbell's Soup Cans*, arguably Andy Warhol's most iconic work, or at the very least right up there with the multi-coloured Marilyns and Mao Zedongs. Legend has it he got the idea when a friend suggested he paint something everybody recognized, 'like Campbell's Soup'. Even by Warhol's standards, the work was sensational, sparking debate about how art could concern itself with something so everyday, mimicking, even celebrating, commercial mass production. When the exhibition opened at the Ferus Gallery in Los Angeles in 1962, a neighbouring art dealer sold actual soup cans by way of criticism, advertising them as 'cheaper than Warhol's'. But pop art lived up to its promise, and it didn't take long before high society in New York was hitting Broadway decked out in *Campbell's Soup Can* prints.

Beside exposing the ease with which the mass market could be manipulated, Warhol's paintings were powerful

statements about the state of advertising in the 1960s: repetitive, boring and unrealistic. Through art, he made people re-evaluate the meaning of mundane items. I wanted to do the same – to reconnect meat, the supermarket product, to its origin: an animal. It was obvious: Pigcasso had to put the brush to a piece of bacon.

We laid our hands on a clinical image, a non-descriptive package of slices of cured pork belly, spent a fortune blowing it up on archival paper and pinned it to the barn wall. It was profound, and slightly macabre. An everyday thing meeting its maker: a feast of contradiction wrapped in a simple message, with a side serving of irony. Talk about making a meal of the mundane . . . the pot was filled with deep pink, but it was up to Pigcasso to make the connection. Without hesitation, she picked up the brush and, almost perfectly, across the bacon slices, painted the side profile of a pig's face. All it needed was an apple in its mouth and carnivores would call it Sunday roast. Another home-run in the longest lucky streak in art history. Or not . . .

Pigcasso Was Here remains one of her most powerful artworks: a battle cry that challenges (maybe even dares)

the observer to 'love' the artist and feel no guilt in eating her. The work strips bare our conditioning to reveal the invisible belief system that supports and encourages the use and consumption of animal products. In her book *Why We Love Dogs, Eat Pigs and Wear Cows*, Melanie Joy gives it a name – carnism – which implies something ideological rather than just habitual or behavioural. Asking people to consider what they are doing won't change a thing. We have to make them ask themselves why they are doing it in the first place. *Pigcasso Was Here* does exactly that. It forces us to question the rationale behind eating some animals and not others, and why we eat animals at all.

Like sexism and racism, carnism is a global system that uses psychological defence mechanisms so that otherwise rational, compassionate people engage in irrational, harmful practices without fully realizing what they're doing. We can't see the animals we're eating because they're perfectly portioned and hermetically sealed. The living beast becomes an 'it' with a price tag: an object, inanimate, like a can of soup. But Pigcasso rips off the blinkers. If a pig painting a pig on a photo of bacon doesn't make you ask tough questions, nothing will.

Even if meat-eating is *de rigueur*, eating the meat of animals that you know have been raised in poor conditions is fundamentally in conflict with the moral principles that underpin supposedly modern, civilized society. And it's a moral conflict that doesn't just dampen our enjoyment of eating meat, it threatens the way we feel about ourselves and our choices. So, in order to protect our identities, we establish habits and social structures that make us feel better. And we package it up all prettily so no one knows the difference, and the cycle of ignorance and bliss continues unchecked. But with this unique work of art, Pigcasso gives us nowhere to hide. Her bacon bits stick in your gullet and make you choke on the truth.

Perhaps then, the original question – what is art? – is no longer relevant. Historians, critics, commentators and supposed experts can conjure up countless theories as to why art is either iconic or rubbish, depending on which side of the bed they wake up on. So can I, and so can you. If Warhol can be credited with prophesizing our own times, fixated as we are on wealth, consumerism, celebrity, glamour, scandal and separation, then Pigcasso may well be doing the same for the middle of the 21st century.

Of all the pressing issues that threaten human existence, the extreme unsustainability of animal agriculture and its contribution to driving climate change *must* be near the top of the 'fix-now-before-it's-too-late' list. Right here, right now, Pigcasso's message could not be more poignant. It's a mess: this wild, complicated, greedy, overpopulated, vulnerable planet, a place where a banana duct taped to a wall can be sold for $120,000, for goodness' sake. It's all hog wash. It's all art.

15.
Pig Floyd

What makes a *Pig Floyd* valuable? That was the name of a Pigcasso artwork commissioned by an anonymous collector from London. I was intrigued with this character. You could see he'd 'done it all': he was Jack Nicholson meets James Bond. He chose pinks and purples and we got down to work. Long story short (very short), Pigcasso completed the mission in less than two minutes. He was thrilled, and had stopped her himself when he felt it was done. I felt somewhat awkward that it was all over so quickly. I found

myself making excuses for her pace, almost apologizing that the experience – for which he'd paid $2,000 – was over in a flash. He smiled, sat me down, and asked me if I had heard 'the one about Picasso'.

Confused, and not sure what Pablo had to do with Pigcasso's Olympic sprint, I sat and listened as he told the story. Picasso finishes dining at one of his favourite restaurants and is walking out when a woman stops him, bats her eyes at him and says, 'Pablo, won't you draw something for me on this napkin. Please?' Surprisingly, he pulls a piece of charcoal out of his pocket, draws a quick sketch of a dove in a few seconds and signs it. It's beautiful. The woman is elated, thanks him profusely and asks how much she owes him for it. '50,000 francs,' says Picasso. The woman is incredulous, outraged and asks how he can charge so much given that it took him only 30 seconds to scribble. Picasso looks her in the eye and says, without hesitation, 'No, madam, it took me 40 years.' And with that, 007 smiled at me, picked up his artwork, turned on his heels and walked out of the barn, making one last turn at the door. 'True story!' he said, and then he was gone. Whether he was right, or if it's just a wonderfully apocryphal story doesn't

matter. It's the principle that's important: perspective prevails. The value of that commission had nothing to do with how long Pigcasso had toiled at the canvas, and everything to do with context: every work of hers is painted on an invisible foundation layer of the story you've just read.

You could devote an entire postgraduate degree to debating the 'price' of art, and people have done just that, for good reason. The international art trade is seriously big business. We're talking $65 billion a year, give or take, which is more than the GDP of 65 per cent of the world's economies. The reason it's all a bit contentious is that, unlike stock or commodity-driven markets, and in addition to the obvious demand-and-supply factors that influence price, there's an enormous amount of subjective value inherent in the system. In the rarified atmosphere of fine art, one man's trash is another's treasure. While Trump values skyrises, the Dalai Lama values freedom. While some value a banana taped to a wall at $120,000, others wouldn't spend $1 on it at the supermarket. It's a matter of perspective, often distorted by a lot of ego, or a complete lack of it. That said, a set of informal 'rules' does exist when it comes to setting the price on a work of art.

Generally, size counts. Bigger is better. And so is colour. The broader the palette, the higher the price. 'Mono' will get you great reviews, but the price won't match. Then there's the obvious economic factor of rarity. And finally, bringing up the rear, there's quality: the subjective distinction between garbage and gold.

Of the small band of eye-rolling cynics who have offered opinions over the years, I most relish getting into 'conversation' with those who ask how on earth we price a Pigcasso. When I'm not in the mood, I just send them in the direction of art dealer Michael Findlay's 2012 book, *The Value of Art: Money, Power, Beauty,* which answers the question and shuts the door. I'm particularly fond of his analogy between paper money and art, which centres on the notion that, just like currency, when art is traded between two parties, it's based purely on collective intentionality. It's no different from two people dancing, or erecting a tent, or playing on a seesaw. Just as a $100 bill costs less than 20 cents to produce, there's no intrinsic value in a painting over and above the materials used, the framing, if applicable, and perhaps a pro rata percentage of the studio rent. To up the price, all that's required is for two people

to have an intention to, and agree to, create value over and above the obvious. Beauty may be in the eye of the beholder, but art's value lies in the 'I want to own that' of its beholders.

Once you've got your head around that, you can start unpacking the secondary market. The moment an artist sells a piece, they have absolutely no control over what happens next, and that's when things start to get crazy. In this la-la land, exclusivity is the ultimate high. It's where one-upmanship and an auctioneer's hammer can turn reasonable estimates into telephone numbers in seconds, where bottles of wine are worth more than some houses and Pokémon cards can buy Teslas. With the creators out of the picture, their creations can assume lives of their own. History shows us that many artists have to die before their work, through collective value in its literal sense, achieves these lofty heights. There's nothing quite like death to limit your editions, so the artists who retire in comfort are few and far between. The pigs who've managed it are rarer still.

Pigcasso has built-in exclusivity. When *Prince Harry* sold for $3,000, there was widespread public reaction and a fair amount of discussion about the rationality of the

—207—

valuation. I was asked for comment and went down the big-picture route. There are approximately eight billion people on our planet. Give each one over two years of age a brush and some paint, and they will all paint something. The quality of the artwork will be subjective, of course. Hand a brush over to each one of the estimated 677 million pigs on the planet and I'll eat my hat if there's more than one who will take the brush in its mouth and spontaneously paint. That's what you call an original; a very rare breed in today's world. And it's why Pigcasso's art is still significantly undervalued and will no doubt increase in value with every passing year. Mic drop.

To appraise a Pigcasso, then, you've got to take all of this into account. Ironically, for us it was never about the money. The money was a wonderful effect; the cause was always the message. I've said it often and it still rings true: the priorities for us were, in order, message, masterpiece, money. At the same time, we weren't completely stupid: no money, no sanctuary. It was an ever-present need that had to be met. The vet bills and hay bales all added up and would continue to do so until only the longest-living animal was standing. Most likely Baloo in 2050, still licking away at visitors at

the ripe old age of 33, long after Pigcasso had flown into the heavens. The stark reality was that *Prince Harry* could provide the consumables required for all the animals and the farm for four whole months. A third of the calendar year. It wasn't a painting sale, it was a long-term plan, going to plan.

When Pigcasso first hit the headlines, it was primarily because her art was extraordinary. It wasn't just because a pig was painting, it was because a pig was painting *that*. The work was distinct, identifiable, compositionally engaging. As we sold and the prices went up, the news became more about the selling price than the talent itself. That sold more, which pushed the prices up even further and we were loving every minute of it. There were discerning collectors who were prepared to pay up to $7,000 for an original Pigcasso – for work from an artist who had only been on the scene for three years.

We had challenged established norms and left a mark, and the vegans were chanting victory. If we had a worry in the world, it was that somewhere in mainland China, hidden away in a factory where knock-off Louis Vuitton handbags and Jimmy Choo shoes were cat-walking their way off a conveyor belt, there was a squadron of pigs, all

saved from slaughter, banging out an endless stream of fake Pigcassos and flooding the international market. But unless we've had the wool pulled over our eyes, no heroic hogs have arrived at the easel just yet. Another factor in our success was that we were continually motivated by positive reinforcement. On our various digital platforms, Pigcasso received millions of hits, views, friends and followers, and it's miraculous that the interactions were all favourable. You could tell when people weren't sure what to think, but even then, the comments were curious rather than critical – and when they were critical, it was always well intended. The comments and questions also broadened my own perspective, providing me with angles I hadn't considered before and ways to further express the value of our project.

With every interaction, every smile and every squeal of delight, our purpose became increasingly clear, our story more refined. The commercial value of an original Pigcasso is calculated by the painting's ability to blur the lines and stake a claim in the no-man's land that lies between the established art world and where it fears to tread. Some will get it, others won't, and there are sufficient of the former to fuel our passion. But the thing that makes

her work truly valuable is far deeper than a price achieved, a sale secured or a sanctuary supported. The 'why' behind everything we do seeds a meaningful narrative and owns it. Every single Pigcasso is a conversation piece. Picture the scene: you're at a dinner party and conversation shifts to a painting on the wall. You recognize it from your art class in high school. It's *Girl with a Pearl Earring,* and your host doesn't miss the opportunity to make sure that everyone knows it's the original. More than 350 years of history is watching starters being served. You can't believe it: you're sitting next to a Johannes Vermeer. Your mind races to conclusions: your host is filthy rich; you may be out of your league; whatever you do, don't touch anything! You overcompensate, play it too cool, make a silly comment about her lipstick colour, recover by asking how they acquired the masterpiece, and then have another sip of Chateau de Whatever. Ah, thank goodness, mains are served! It's roast pork, and the conversation turns to skiing holidays. The next morning, when the hangover subsides, you know you had dinner with an original Vermeer, but it's not much different from seeing the Eiffel Tower for the first time, or the time when Tom Cruise had dinner next

to you in a schnitzel bar in Berlin. Just another anecdote in the diary of your life. You grab a flat white and hit the start button on another day.

Now consider you go to the same dinner party and the host points to the wall and says, 'That, my friends, is an original Pigcasso!' Doesn't look like a typical cubist masterpiece, you think, and you say so. He repeats himself, a little slower this time: 'It's a Pig-casso'. The table raises a collective eyebrow. Come again? That artwork was painted by a pig? Impossible. He smiles knowingly and airplays a video from his phone to a smart TV hanging on the opposite wall. There she goes, picking up the brush without anyone twisting her trotters, swishing away with gusto. There's no green screen, no stop motion, no hint of CGI. It's remarkable to say the least, and it's a moment that changes the course of the evening completely. How much was it? Where is that beautiful barn? Is it art? Pigs are so smart, aren't they? Are they? George Clooney has a pig. Really? Is that just lucky or does the pig know the alphabet? Does this loin roast taste a bit funny? The conversation lasts well past midnight. Turns out three of the guests have been to Cape Town, and two are planning

a trip this December that includes a weekend in, no way, Franschhoek! As memories are shared and the roast goes cold, you realize that strangers just became friends and the world is a slightly better place than it was before you all sat down to eat. You leave inspired and invigorated: your head is buzzing for all the right reasons. You wake up the next morning and before you even smash your first cup of coffee, you switch on your iPad and google 'Pigcasso'.

Which of the two paintings has more value? If you're in the 'money and ego' corner, the pearl earrings are all yours, bud, and here's hoping you and the Kardashians find something more interesting to do than shop and gossip on your annual holiday to Mar-a-Lago. But if you value more cerebral and meaningful things in life, if conversations that challenge, intrigue and inspire make you feel truly alive, well, give that hog a call.

For me, the final piece of the pricing puzzle, the value-added-tax rebate if you will, is that anyone who invests in a Pigcasso is buying a karmic cycle for the intellect, or at very least a philosophy course with unlimited lifetime access. Because the message is as layered as the work itself. The more you look, the more you think; the more you think,

the more you question; the more you question, the more answers you find. And the more answers you find, the deeper you want to look. By peeling away the layers of meaning, Pigcasso's work forces us to pause and ponder some pretty fundamental questions about the human condition, and our strengths and weaknesses. When you watch her paint, it's impossible not to smile at the sense of sheer joy and unbridled freedom of the artist. She is always in the moment, always spontaneous. It's pure creative flow.

There's a famous quote often attributed to Picasso: 'Every child is an artist. The problem is how to remain an artist once he grows up.' It neatly sums up the reality of being passengers on a supposedly *sapiens* human journey. Our Western education system frames reality in right and wrong answers, supplies us with rules, enforces them with examinations, and rewards adherence to the system with certificates and prizes for being 'first in class'. It's only when we leave the manufactured safety net of accepted norms that we realize the world truly is an oyster: it was just closed. All we need do is prise it open to discover hidden treasures.

We start out like a free-flowing pig, but all the bullshit we learn along the way slowly destroys our flow and we're

too young to know better. We get trapped in a system and, if we're lucky enough to recognize it, we're going to spend hours, weeks, months trying to find a way out. We are all Neo, we're all looking for the Oracle, and our ability to escape the matrix is totally dependent on our willingness to embrace, or create, a different reality. If you take the red pill, you really can rediscover the child who once lived in a magical kingdom of powder-paint unicorns and glitter-glue rainbows.

Pigcasso's undistorted self-expression also throws down the gauntlet and asks us to consider: do we discard the value of animals only because we're judging them from our own limited perspective? All of life's great lessons start with a single question: What if? And in that sense, Pigcasso's art is a far more powerful catalyst for change than any self-help book or Oprah moment of vicarious awareness. Pigcasso is a teacher; her works are the message. How do you hang a price-tag on that, I wonder?

There's one final value attached to Pigcasso's work: *it saves lives.* Her art funds the food and veterinary services for all our animals, the staff wages, educational material, the general operations and so much more. If you visit

Farm Sanctuary SA, you'll see, touch, hear, smell and feel the real value of a Pigcasso. You'll meet Baloo, Moo'tise, Piggie-Sue, Mona Lisa, Rosie, Herbie . . . You'll see hundreds of chickens that we've saved from intensive layer hen factories, where they would have been confined to wire cages barely bigger than their own bodies; where all their captors would have cared about is that they laid an egg every 26 hours. For the next five years. Pigcasso is the main reason why these birds can feel the sun on their backs, squabble over seeds, scratch around in the sand and, in time, maybe even grow their feathers back so they look more poultry than reptile. You'll also meet the rest of our family, who began at the sanctuary at its very inception. Ask Evelyn how commission on the sale of Pigcasso works has enriched her life: a small house of her own, a retirement plan, a passport to the world. Ask John how he's able to support his entire family in Malawi and wake up in the morning with a sense of pride and belonging. They both ensure Pigcasso is treated like the royalty she is, and in return, she bestows on them the favour of the crown.

16.
Peppa, Porky & Piglet Babe

Mirror, mirror in the stall, who's the most popular pig of all? That's a tricky one, because the evidence suggests we've been infatuated with swine kind for a long time. Like, forever. In early 2021, archaeologists working on a cave site called Leang Tedongnge on the Indonesian island of Sulawesi stumbled across a perfectly preserved red ochre painting of a 'warty pig' that they were able to date to 45,500 years ago: the oldest known artwork of an animal. Unbelievable. And it's the ancestor of a sizeable

drift of real and imaginary pigs that have left their mark in the history books.

From the earliest of times, we've had a complicated love-hate relationship with pigs. They feature in hieroglyphs in ancient Egypt; clay pigs pop up in archaeological sites all over the world; and they even play a starring role in the religious texts of the world. In fact, pigs very nearly got an everlasting 'get out of jail free' card when the Abrahamic religions started recording their thoughts on papyrus scrolls. The Quran forbids the 'flesh of swine' outright, and in the Bible's Book of Leviticus, there's a famous rule along the lines of 'you're not allowed to eat the pig because it has a cloven hoof and doesn't chew the cud'. But that's all there is, and there's no underlying reason or rationale given as to why it should make any difference to anyone. It's just plonked in the text. And after that, the pig is relegated to the ranks of the 'unclean'. In one story, Jesus casts a couple of demons out of some possessed guys into a herd of innocent pigs hanging around on a hillside, who immediately tumble into the sea and drown themselves. Hardly a shining example of peace, love and understanding, but let's not go there . . . The net result is

that for Jewish and Muslim people, eating pork is strictly forbidden – which should be good news, because that accounts for about a quarter of the world's population and Islam is also the fastest-growing religion in the world. But here's the problem: the elders who decided how to interpret Christian scripture decided that the Old Testament stuff about cloven hooves was only a deal between God and the people of Israel. And abracadabra, a twist of fate gave 30 per cent of the human race the green light to eat pork.

Yet pigs were once considered sacred in some cultures. The druids of Celtic Ireland certainly thought so, and if you go even further back to ancient Europe, pigs were often associated with female goddesses and worshipped as being divine symbols of fertility and the cycle of life and death. The first really bad era for pigs may well have been the switch to monotheism, the rise of patriarchal structures and the suppression of anything resembling girl power. Why pick on pigs? Because of all the large domesticated animals, they are the only ones that give birth to litters: ten piglets at a time, at least, twice a year. There's just no comparison with, say, cows, which deliver a single calf a year, at best. Being highly reproductive is a double-edged

sword, since it also means you're a highly productive machine for meat-eaters. Which may explain why, in the very first recipe collection we know of, *De Re Coquinaria*, attributed to Roman gourmet Marcus Apicius, there are more recipes for pork than for any other meat.

To complicate matters further, consider this: from the cold-hearted perspective of the farmer, live pigs aren't much use. Cows and goats give you milk, sheep give you wool and chickens make omelettes. But the only thing pigs can offer to us while they are alive is love, so the humble porker has been destined to live a double life. On the one hand, there are the truffle-hunters, who idolize the best snouts in the village. Considering that the fabled fungi can sell for anything up to $4,000 a kilo, you would too. And in countries like Germany, and some Nordic territories, New Year's Eve wouldn't be the same without someone handing you a marzipan Glücksschwein, a 'good-luck pig' to wish you well for the coming year. On the other hand, when something goes wrong in Italy and someone shouts out *'Porca miseria!'*, the sentiment is hard to miss. People all over the world are in the habit of using the pig's name in vain. There's probably no other animal that gets as much

airtime in idle conversation; from dirty pigs to pig-ugly patterns, there's no shortage of sayings that slander the swine. What's really unfair about it is that pigs are some of the cleanest animals in nature, when they're actually allowed to be in nature.

'Eat like a pig' *is* perhaps a fair turn of phrase, and Pigcasso hasn't done much to prove that wrong. But if you ever think you're sweating like a pig, think again. Pigs don't have sweat glands. We sweat to cool ourselves down, but pigs can't do that, which is generally why they wallow in mud, just like elephants. But you never hear anyone say they're 'sweating like an elephant', do you? Ironically, the term is misunderstood. Although there's some debate in word-nerd circles about the derivation of the term, we know for certain that 'pig iron' has been used since the late 1600s to describe the crude iron made in a blast furnace. The hot metal is poured into sand moulds resembling the limbs of a tree, with many ingots branching off from a central channel, so it looks like a sow and her piglets. The theory goes that as the metal cools down and hardens, water droplets form on the outside and when it's 'sweating like a pig', it's safe to handle.

We appreciate it when someone 'saves our bacon', imagine impossible days 'when pigs might fly', and if we do something really thoroughly, we'll beam with pride at having gone 'the whole hog'. But at the same time, when the Black Panther movement in the 1960s was looking for the worst thing in the world to call the police, it adopted the slang term 'pigs'. The women's lib movement went a similar route, and ever since we've scoffed at male chauvinist pigs. And let's not start with all the quotes from famous people that throw shade at pigs. One, which is variously attributed to George Bernard Shaw, Mark Twain and Abraham Lincoln, perfectly expresses the mean-spirited attitude towards these amazing creatures when it says, 'Never wrestle with pigs. You both get dirty and the pig likes it.'

I can't help feeling that a large part of our uncomfortable relationship with pigs is because they really are more like us than any other animal. We both have eyelashes, protruding noses and hairless skin. We have eerily similar-looking eyes. Our dental structure is identical (down to having baby-teeth), our digestive systems are a near match and we're both omnivorous. We can even 'use' various parts of the pig as substitutes for human body parts: like pig skin or pig

heart valves. Actually, make that the whole pig heart, thanks to the first ever successful xenotransplantation in history at the University of Maryland Medical Centre in January 2022. A genetically modified pig heart beating in a human chest. Welcome to the future.

No wonder pigs keep popping up in our lives, not only as fictional characters, but also as real-life heroes, like Pigcasso. There's LiLou, a certified therapy pig who visits San Francisco International Airport twice a month on a mission to de-stress passengers and airport staff. There's Esther the Wonder Pig in Canada, whose chirpy social media posts and bestselling book have made people look at pigs differently, and who inspired her humans (Steve and Derek) to launch the Happily Ever Esther Farm Sanctuary in Ontario. Thanks to social media, there are also dozens of piggy influencers on the web, ranging from Bacon the Piglet in Texas to Priscilla and Poppleton from Florida, who have over 600,000 followers on Instagram.

Like millions of children and grown-up children all over the world, my favourite literary characters are all animals. First among equals has to be Wilbur, the pig from E B White's *Charlotte's Web*. First published in

1952, this all-time classic tells the story of Wilbur, whose friendship with a barn spider called Charlotte saves his life. Born as the runt of the litter, he was destined to end up as bacon, but the farmer's daughter pleads for his life and raises him as a pet until he is sold to her uncle, who's only got one thing in mind: fattening the pig up for slaughter. Charlotte comes up with a plan to save Wilbur from his fate, writing messages praising him in her web (the most famous being, 'Some pig!') that turn the barn and Wilbur into a tourist attraction and make him far more valuable alive than dead. I'm sure you will understand why it has pride of place on my bookshelf.

Hot on Wilbur's hooves is Piglet from A A Milne's *Winnie-the-Pooh*, illustrated by E H Shepard. Countless books and essays have been written about the depth and symbolism of the friendship between the endearing, honey-loving Pooh and his closest pal, Piglet, whose tiny frame and nervous disposition are always countered by an inner strength and courageousness. There's a special moment in A A Milne's *The House at Pooh Corner* that's followed me around ever since I bought a greeting card many years ago, which I've kept in my desk drawer to this day. Now faded

and bearing a few coffee stains, it's a page I've pondered over often in my life: simple drawings and simpler words that resonate with my deep love for animals. It shows Pooh walking with Piglet, who's always a little fearful. In this instance, he reaches for Pooh's paw and when Pooh checks to see if anything's wrong, Piglet says, 'I just wanted to be sure of you.' There's so much in that one scene that touches my heart: the promise of safety, the security found in companionship; the endearingly false bravado.

It inspired the words etched into the barn facade at the sanctuary ('Our lives is our message'), a reminder that it's a little piece of paradise, compassion and empathy where farm animals can feel safe. In the bigger scheme of things, it's how I wish the whole world to be. It's an acknowledgement that even if we can't change everything, we can certainly do our bit. And if everyone changed something, even a little bit, for the better, then perhaps we really could change everything.

The third massive pig on paper – in modern literature anyway – has to be Napoleon, the leader of the revolt in *Animal Farm*, George Orwell's 1945 novel written as a satire against communist Russia. While I wouldn't call it a

favourite (Orwell terrified me with *1984*), the underlying message is too powerful to ignore. It's the story of a group of farm animals who rebel against their oppressive human masters, hoping to create a more egalitarian society. Unfortunately, the pigs, the intellectually superior leaders of the coup, end up creating a system that's even worse than the old one. Perhaps Napoleon's most divisive act comes in amending the founding rule of the new society, 'All animals are equal', to read, 'All animals are equal, but some animals are more equal than others.' In essence, one group's utopia almost always ends up being another's dystopia. The genius of Orwell's storytelling is that his themes are timeless. When I picture Napoleon, I think of factory farming and our hunger for power that all too often leads us down the path of tyranny and dominance over the vulnerable.

While pigs in paperbacks often lean in a deep or dark direction, the ones on screen, big and small, are generally a lighter bunch. From Porky Pig's stutter, which became the Looney Tunes sign-off, to Pumbaa upstaging Simba in *The Lion King* and, more recently, Peppa Pig's family outings and Olivia the Pig's adolescence, there's no

shortage of pigs stealing the limelight. Any *Simpsons* fan will know (and love) Plopper, the pig Homer adopts from Krusty Burger, saving the animal from ending up as a sandwich filling. He appears now and again hunting truffles and causing trouble throughout the episodes, but is probably best known for his role in *The Simpsons Movie*, where he becomes 'Spider-Pig' and walks on the ceiling with a little help from Homer. The role even inspired a hipster collective in Cape Town to release a series of wines featuring a cartoon pig in a Spider-Man suit on the label.

And then, of course, there's the small screen's original porcine prima donna, Miss Piggy. From the first time I ever watched Jim Henson's *The Muppet Show*, Kermit the frog had nothing on Miss Piggy. What's not to love about a temperamental superstar, without a hint of grey hair, who is unapologetically herself and has a tendency to use French phrases and karate kicks as and when needed? The show was my absolute favourite to watch as I chewed through my defrosted mash and steak-melt TV dinner, the super-processed pseudo-cheese oozing through its captive-beef centre and lodging somewhere between my input and output valves for weeks. (How I managed to pass

high school fuelled by that, only my favourite teacher, Di Black, will ever know . . .)

But my all-time favourite pig – besides the one I know so well in Franschhoek – has to be Babe, babe! I mentioned this earlier, but it deserves special attention because, apart from being a marvellous bit of film-making, *Babe* had a very special effect on the world that had nothing to do with digital enhancement, surround sound, Coke or popcorn. *Babe* the movie was adapted from Dick King-Smith's book *The Sheep-Pig*. Although the book was set in England, the movie takes place in Australia because director George Miller (famous for *Mad Max*) was an Aussie and insisted on shooting at home. The storyline – an orphaned pig growing up to be a famous sheep-herder – remains the same, though, and it all begins when Babe is orphaned after his mother is herded to the slaughterhouse and saved by Farmer Hoggett. We're constantly reminded of the fragility of Babe's life as Mrs Hoggett, with an eye to Christmas dinner, measures the growing piglet throughout the movie.

Farmer Hoggett was played by American actor James Cromwell. At the time he took the role, he had very much been a character actor, so when he first read the script he

thought it was a bit silly – after all, what sort of leading man gets only 17 lines? In interviews over the years, he's confessed that a good friend convinced him to take the part, arguing that it was a free ticket to Australia and that if the movie flopped, he could always blame it on the pig. Cromwell flew down under, sealed the deal, and effectively made his career. To say *Babe* was a smash hit is an understatement. When it was released in mid-1995, the film grossed $255 million against a budget of $30 million. It won 13 international awards, including the Golden Globe Award for Best Motion Picture – Musical or Comedy and the British Comedy Award for Best Comedy Film. It was nominated for no less than seven Academy Awards, with Cromwell, at the age of 55, getting an Oscar nomination for best actor – and, incidentally, at 2m in height, becoming the tallest person ever nominated for an Academy Award. *Babe* may have walked away with only a single Oscar for Best Visual Effects, but hey, that's not bad considering it was one pig and a farmer against the crew of *Apollo 13*, *The Usual Suspects* and 6,000 Scottish warriors avenging Braveheart.

What *Babe* certainly did win was a few million hearts, and ultimately the movie left a far more meaningful legacy

than a statuette collecting dust on the mantelpiece. In its immediate aftermath, the US Department of Agriculture reportedly showed stagnant demand for pork, while retail sales of canned meats like Spam hit a five-year low. In fact, the vegetarian spinoff of the movie became so widespread that it was dubbed 'The Babe Effect' and fans who went meatless became known as 'Babe Vegetarians'. Among those individuals whose eating habits were forever altered was none other than James Cromwell. A lifelong and outspoken political and civil rights activist, Cromwell had also turned vegetarian in the mid-1970s, after witnessing first-hand the madness of a Texas stockyard. During the filming of *Babe*, he managed to take the next step and go fully vegan. In the years that followed, he became a leading voice for PETA, and even managed to get himself arrested for protesting against SeaWorld's treatment of orcas.

When the director called a wrap for the last time, Cromwell made sure the 48 pigs that played Babe in the movie would live their best lives and personally arranged for them to be allocated to educational farms and schools. And it didn't stop there. A few years later, in 2003, Cromwell

was back in Australia and was persuaded to appear in photos with a pig as part of an animal-rights campaign. After taking the shots, the pig, who they'd saved from a local breeder, was given to Pam Ahern, an equestrian also involved in animal rescue work. She named him Edgar Allen Pig, and the two were inseparable for the next eight years until he died peacefully in 2010. Because Edgar had needed a suitable home, he was the inspiration to set up the Edgar's Mission Farm Sanctuary in Victoria, which has provided a safe haven for thousands of rescued animals in Australia for the past 20 years.

So yes, I'm a Babe-eliecer, a fan for life. It shows how the right story, told in the right way, can create ripples that turn into tidal waves. It seems to me the stories we love most are those where the main character (especially when it's a pig) embarks on a classic hero's journey and finds a way, usually with the help of another animal, to avoid landing up on the menu. When it happens, we're bowled over by the animal's fight against adversity, the way he or she manages to avoid the humanoid salivating at the thought of its dismembered body parts. We leave the cinema inspired and joyful and relieved – and often a little self-righteous.

But how can we boo the farmer or the butcher for 90 minutes, then forget all about it next time we're in a supermarket looking for a quick animal-protein fix? Like dirty laundry, it's a problem. And here's what I know for sure about dirty laundry: firstly, it doesn't clean itself, and secondly, you can try to hide it in a cupboard, or zip it up in a gym bag and leave it in the boot, but eventually it will stink up everything. So how about we lay it all out on the floor and see if we can stop the stench? Or maybe it would be more appropriate if we just hang it on the wall, next to a glorious painting by a soon-to-be famous pig.

I guess of all my lofty ambitions and hopeful dreams, the greatest is the possibility, even an outside one, that Pigcasso could one day be held in as high regard as this elite, and erudite, group of famous pigs. No, she'll never be as fearless as Napoleon, as pretty as Miss Piggy or as cute as Babe, but she's already made her mark on the human world in a meaningful, impactful way, and it's an impression that may well last a lot longer than we think.

Unlike movies and television series, and perhaps even literature, the art world has always had a sort of built-in longevity factor that must be the envy of more populist

platforms. In simple terms, you get the feeling that the Mona Lisa will be relevant forever. Did you know that oldest work of art in the Louvre, the 'Ain Ghazal statue, is over 9,000 years old? Technically, it's an artifact, but in form and function, if you snuck it into a Henry Moore retrospective you'd be hard-pressed to pick it out as an impostor. Art that makes a difference, art with intent, really is timeless. So sometimes, late at night, when no one's listening to my thoughts, I try to picture a gallery wall at an exhibition of the most influential artists of the early 21st century. There's Damien Hirst's *Flumequine*, Julie Mehretu's *Dispersion*, Ai Weiwei's *Circle of Animals/Zodiac Heads* and, of course, the Banksy classic *Show Me the Monet*. And there, in the middle, is a Pigcasso, standing out from the rest because of an unmistakable energy projecting from the canvas, yet blending seamlessly into a wall of modern masterpieces. Can you see it too? I thought so.

17.
Say It, Without Saying It

Whatever dreams we have of possible futures, if Project Pigcasso ended tomorrow for whatever reason, we've at least made a lot of people ask some very basic questions about the world we live in, and the way we live our lives. And although we can't force anyone to come to the same conclusions we have, just asking questions is surely step number one on the journey toward a more loving, caring and compassionate world, don't you think?

I can't tell you how many people visit the sanctuary,

meet Pigcasso and declare it's the first time they've met a living, breathing pig. The painting is just the cherry on top! It's no one's fault, but rather the result of a modern society that is so far removed from nature in general, and our food sources in particular, that we're sitting ducks in the pond of consumerism. Here's an example: do you remember a decade or two ago when '100% grain-fed beef!' was the promise made on the menus of the best restaurants in town? How many people stopped and asked, 'Hey, wait a minute, don't cows eat grass?' Every now and again, there's a glitch in the matrix: 'Cows escape slaughterhouse in LA and run past Brad Pitt mansion.' Or a pig-laden truck overturns in Vegas, or a live transport ship carrying 15,000 sheep capsizes off the Romanian coast. But we barely have time to raise the obvious question, 'What the heck were 15,000 live sheep doing on a ship?' before the front pages are once again dominated by celebrity weddings or pixelated pictures of Lady Gaga tanning topless in Saint-Tropez.

In my younger days, I spent countless hours on the soap box of activism trying to open people's eyes. Some of the stories beggar belief, like Yaji – which ironically means 'sacred' in Mandarin – a few kilometres south of the city of

Guigang in southern China. I'd tell people that if you were to visit the place, you'd see a series of huge, grey concrete blocks, many storeys high, that resemble some sort of secret military facility. But what you'd actually be looking at is the tallest factory farm in the world. Units up to 12 storeys high house thousands of pigs (1,300 on each floor, to be exact), which will eventually produce, according to a report by the *Guardian*, almost 850,000 pigs a year, all bred in a bio-secure facility that is purpose-designed to combat the spread of disease. Unbelievable? Maybe, but not surprising. Given the industrialization of animal farming on a global scale, it's both a sign of the future and a reflection of the past. With over 1.4 billion people to feed and a cultural association with eating pigs that results, according to AgWeb figures, in a staggering annual consumption of over 20kg per person, China is now the largest pork producer in the world. Of the 420 million pigs it breeds every year, 65 per cent are raised in intensive facilities where the animals will never see daylight. Are they actually pigs?

Despite my best efforts, I have a suspicion that when it comes to eating animal rights, a 'burning platform' approach is simply too hard for most people to swallow. Which is why

Pigcasso is so incredibly important. The painter Paul Klee believed that 'art does not reproduce the visible; rather it makes visible.' It's this aspect of what we have achieved to date – Pigcasso's undeniable presence – that makes me most proud. With every headline, every article and every single stroke, she makes pigs visible. She is an inconvenient truth, giving pork chops a face, adding deep and soulful eyes to that beloved pack of bacon. She is meat in context.

In a rare instance of deliberate execution, I set out to capture, with Pigcasso's assistance, the concept of invisibility. The result was a work called *Stand By Me*. I wanted us to make a statement, so the canvas of choice was a cow hide. Over a series of weeks, blacks, browns, whites and a dash of pink spread across a hide that was pinned to the barn wall. Besides the absurdity of a pig who had escaped slaughter painting on the hide of a cow who had not (Pigcasso even paused in front of it as if to ask 'Why?' before she commenced), we wanted to tilt the prism: to make the familiar unfamiliar and force the viewer to see a common object for what it really is. It's remarkable how 'hidden' cow hides are once we take them off their owners. We walk around in them a lot of the time.

We drape them over our shoulders as status symbols and fashion statements and around our shoulders to protect us should we fall off motorcycles. Rock stars turn them into long, tight trousers to drive the fans wild.

Stripped of the utility value that acts as an invisibility cloak, *Stand By Me* is framed in irony and, at the same time, presents the viewer with a bit of a conundrum. Covered in paint and hung on the wall, the invisible becomes visible. People don't walk over it anymore. They notice it and look at it. They are intrigued. But it's the paint that has made the cow visible, not its own skin. All it has taken to elevate an animal from obscure to visible is a little tube of pigment purchased in an art shop. It's all part of a simple philosophy: we would be living in a very different world if people were better informed – and if there is any good news it's that right here, right now, in the third decade of the third millennium of the current era, there is a growing sense among educated people that something is very, very wrong. And I am ever mindful of how fortunate I am to have Farm Sanctuary SA, where I can witness these living farm animals every day and appreciate them for the individual, unique, extraordinary beings they are.

As a team, we all share a plant-based diet, we all focus our efforts in different ways and we are all cognisant of how our actions impact others. Painting with Pigcasso and inspiring others to reconnect with the source of their food allows me to survive in a world where I often feel I don't really belong. In my world, animals don't want to die, and they don't have to. Not until it can't be helped . . . On a sandstone tile that sits above the entrance to the stone cottage at the sanctuary is the Sanskrit mantra: 'May all beings everywhere be happy and free, and may my thoughts, words and actions contribute in some way to happiness and freedom for all.' That is my maxim, the principle according to which I try to live my life. This book, my creative journey with Pigcasso, all the animals that have transformed my life, have inspired me to pursue and honour this message. I choose to be conscious. I choose to be morally accountable. I choose to care about others. I choose to act (and eat) according to my convictions, regardless of what other people are doing. None of which make me special in any way. It makes me human.

18.
A Chilling Turn of Events

In the spring of 2022, things began to slow down. Not sales, or Pigcasso's love of painting. But it was clear from the way she was moving that things just weren't normal. Or rather, the way she wasn't moving. At first I wasn't too concerned; we had gone through two very similar experiences, six months prior and a further six prior to that – days when Pigcasso simply struggled to get up. We always assumed that it was an issue for Weight Watchers. Over the years we'd gotten quite used to it, but the fact was

our sanctuary could easily be mistaken as a halfway house for recovering drug addicts. Before I managed to snatch her away, there's no doubt Pigcasso had been pumped full of growth hormones, which is standard practice in an industry that aims for maximum growth in minimum time, with the most profitable body parts unnaturally enlarged. These animals aren't meant to make it past six months, so if they do, chances are they'll land up like Pigcasso. Her body is incredibly huge, her legs so short and small that she often limps around, and occasionally she's in such obvious discomfort she can't get up.

In previous scares like these, we had always called the vet, who gave us the advice we suspected: put the pig on a crash diet 'like yesterday' and give her occasional doses of Metacam (an anti-inflammatory) to control the swelling associated with osteoarthritis. It had always worked. After a few days Pigcasso would come right, although she always knew it was me who was responsible for the rationing, and it took a couple more days for her to forgive me for holding back the bananas. Lighter on her feet, Princess Pigcasso would go right back to her royal routine: eat, sleep, paint, breathe and live as large as possible. And both

times there was a silver lining because, once she'd bounced back, it seemed as if we went through spurts of creative excellence, as if a glimpse of doom had given us a kick in the collective butt. It had left us all feeling a bit bulletproof: we understood the situation and knew exactly what to do. If we managed her weight and kept the arthritis in check, we could keep her happy and healthy and all would be well. The universe was on our side. Or so we thought.

In late 2022, a group of Americans had placed a commission and had driven out from Cape Town to watch Pigcasso paint. They'd chosen a rare palette of pale pinks and beige creams. Big fans, they sat and waited with the enthusiasm of courtside seat holders at an NBA basketball game. I gave them the usual introduction and outlined how things would unfold in the next hour. I explained, as I always did, that the painting process would be a relaxed, slow experience. And I explained that whatever was about to happen, the morning (and the masterpiece) was entirely dictated by Pigcasso. Thumbs up, heads nodding, all in agreement, let's go! Despite the build-up, I felt a bit of pressure, as I always did: my ego was firmly in the hands of one mighty pig. I had the routine down pat.

Smile confidently and . . . 'My friends, Pigcasso has never disappointed, and no matter what she does, remember your commission will be a certified Pigcasso and the most original artwork on the planet!' The mood was magical, the anticipation palpable, their sense of wonder and delight filling the entire barn. John had headed back to Malawi for his annual leave, leaving his second-in-command, Clint, to take care of things in his absence. I signalled to Clint to get Pigcasso up and out, and we all waited for her to appear from behind the large barn doors. And we waited. And then we waited just a little bit longer than was comfortable.

Pigcasso did eventually appear. Slowly; far too slowly. I knew something was wrong as soon as she hit the first sunbeam, her back legs fully straightened like a soldier on parade. The stiffened walk was worrying, we'd seen it before, although this time her back also appeared notably curved like a half moon. But what was clearly different on this particular morning was her balance. A blind-drunk pig, perhaps? Impossible. She wobbled (or was that a stagger?) to the canvas, and then stopped. She looked around, swayed a little and then started to turn around. I looked at my team, concerned but also frustrated, as if to

silently blame them for whatever was going on. Had they been feeding her too much? And jeez, what were the guests thinking? Was Pigcasso okay? She was looking straight at us, but clearly off balance. Was the floor wet, maybe? My mind was sliding around the place worse than the pig.

I was trying to hold it together, but what was unfolding was increasingly difficult to laugh off. Pigcasso was hesitantly placing each back trotter alternately on the ground, on tip toes, barely touching the ground before lifting them up again. She'd either been taking modern dance lessons or it was just too painful for her to touch the ground with any weight. There were only two ways to go: panic visibly and freak out the clients, or turn into a bumbling idiot and buy some time. Option two seemed like a better idea. I started babbling about how she was just messing with us, that it was perfectly normal, nothing to worry about here, folks. She just needed the bathroom; we'd go for a little walk and she'd be right back. Don't go anywhere! Would they really fall for it? As if on cue, Pigcasso set off in the direction of the grassy area a few metres away, like a shopping trolley with wonky wheels, and rubbed herself against the umbrella stand. Ah, that

was more like it. A familiar little habit that she had loved since she was just a piglet. All good, then? Apparently not.

Itch suitably scratched, she lurched forward a few more yards and then capsized, dropping to the ground and somehow landing up in a weird seated position. I had seen her do some extraordinary things in our time together, but this was a whole new party trick. My heart was pumping. Very fast. And so hard I worried that the guests might hear it in what had become an uncomfortably silent scene. But I was in it now, and the only thing to do was keep going, and not feel like I had to explain anything to anyone. What mattered was Pigcasso, and all I could do was give her the space to stay put, do whatever or go wherever. After the longest few minutes imaginable, and under the watchful gaze of some very, very wide eyes, Pigcasso rocked from side to side as if building up momentum and finally stood up. To my relief, she didn't mess around at all, made a beeline for the canvas, picked up the brush and started to paint, as if nothing at all had happened. It was remarkable. The guests didn't know any better, but her strokes were shorter and slower than normal. It took a while, for sure, but Pigcasso rose to the occasion and completed two paintings,

both sealed with a few clever and calculated strokes and her trademark snout-signature. As always, they were one-of-a-kinds, and the guests absolutely loved them.

I entertained the Americans for another hour while Pigcasso ambled back to her sty at her own pace, and when I finally left the barn that morning, I felt a massive wave of relief. It was without doubt the hardest day I'd ever experienced with Pigcasso, both artistically and emotionally. It was a challenge on all levels – mind, body and spirit – and certainly not the way it was meant to be. What on earth was going on? The wobbly walk, the soldier trot? My gut told me it would take more than a padlock on the fridge to solve this one. If this was arthritis as usual, why was it getting worse? And most of all, was the poor pig in pain? I needed to make a call and I needed to make it fast, because the timing couldn't have been worse. John wasn't due back from Malawi for another seven days, and I really did have a train to catch. Well, a plane, but that's not how the saying goes.

I was scheduled to fly out to Iceland the following day. It was a trip I'd been planning for ages: a mental and physical investment in a Wim Hof retreat and a healthy dose of

cold therapy. The sanctuary, my animal family and other responsibilities had pushed my limits and I needed a reset – which is a very mild way of describing what lay in store. Bikinis on ice aren't fun, per se. They're a commitment to stepping outside of a comfort zone and learning how to 'die' each day in order to know how to truly live. Bottom line: I had no option. I had to be on that flight, but leaving everything in limbo was going to dampen my spirits more than any sub-zero plunge pool. I needed a vet.

Unfortunately, everything with four legs and a tail in the Franschhoek valley had chosen that particular day to fall ill, but I eventually tracked down Neil Moelich, horse and wildlife vet, who worked at the same practice as our regular vet. He was the senior honcho and knew all about Pigcasso. What he didn't know was that her condition was clearly deteriorating and I begged him to come out as a matter of urgency. I sent him a few videos of her stumbling around so he could give it some thought before arriving. He managed to make it before the sun went down, and gave Pigcasso a thorough examination. He pressed and pushed every limb. He had her stand up, sit down, stand up. He nudged and poked and prodded in the most gentle way. There was

nothing to do but to watch, wait and pray. And I heard myself gabbling like a concerned parent: 'I know she's too heavy, Neil. We can put her on a diet, Neil. The Metacam should also work, right?' Neil was quietly focused and went about his business, making notes and taking samples. He finally left saying he would call and give me feedback in the morning. I went to bed that night feeling relieved that we'd had the best possible assessment, and Pigcasso seemed to be comfortable as long as she was lying down. There was nothing more I could do except pack my bags and enjoy a good night's sleep in my own bed. Hopefully I'd have promising news in the morning and be clear-headed enough to enjoy a week of stargazing under the Northern Lights.

'Hello, Neil. Let me guess: she has to lose weight, right?' I babbled out before Neil (or the Nespresso machine) could even say, 'Hello.' The good night's sleep hadn't exactly turned out the way I'd planned. My head was too full and I'd been up with the roosters, literally, waiting for the phone to ring. The rest of the conversation was a blur, but the words still punched me in the gut. Pigcasso was dealing with a neurological condition. Neurological. For once, I was speechless. Neil was using terms I'd heard in

my first and only semester of vet school. And I knew that 'neurological' meant I basically had no influence on the situation. Arthritis, we could work around. There were supplements, massages, diets and so forth that would at least alleviate the symptoms, make her comfortable and allow her to move around. But neuro-anything put us in a whole new world of unknowns in the middle of Pigcasso's spinal cord.

I tried really hard to take it all in as Neil patiently explained it was a spinal issue. Her current condition actually had nothing to do with her weight or arthritis, although that certainly didn't aid the situation. Her spine was compressed, which explained the strange hammock-effect. He summed it up quite simply. Either she was going to slowly recover, or she would deteriorate rather rapidly. If she couldn't get up, there would be a number of life-threatening complications that would arise.

I knew what he was saying. There was a good chance that sooner or later, if she went downhill, we'd have to make the call on whether it was better to end her suffering. When horses develop this issue, they undergo an MRI scan, which enables the vets to see exactly where the problem

is, but the machines have a strict weight limit of 200kg. It was the medical equivalent of body-shaming: an MRI wasn't an option for Pigcasso because she wouldn't fit. In reality, though, even if she could have the scan – what then? There was no way she could undergo surgery; it was far too stressful and with her weight and condition, simply too risky.

I put down the phone. What now? Neil had done his best to answer all the questions, but it left me hopeless and helpless. What had really caused it? Was it something I'd done without thinking? Why Pigcasso? Was this the end of the beginning or the beginning of the end? There really was nothing more I could do than bawl my eyes out that afternoon, all the way to the airport, through passport control, into the departure lounge and onto the plane. Everyone kept asking if I was okay and I just said I was dealing with a personal loss. I felt a sudden urge to rush back to the farm and thank Pigcasso for being alive. To tell her what a wonderful superstar she was, and that we'd do everything possible so she could enjoy the last days of her incredible life. To tell her the team would be there for her, whatever she needed, any time of day.

I took comfort in knowing that whatever happened, I hadn't wasted a moment. Having lived through the sudden loss of Oscar, and knowing that Pigcasso wouldn't always be around, I'd made sure that we'd left as few 'what ifs' as possible on the table. On a purely practical level, I'd also made a point from the very beginning of squirreling away paintings, so we had sufficient inventory to sustain the sanctuary for a while. Her legacy was in far better health than she was. The irony was that from a purely artistic perspective, I'd had the feeling that the work we'd produced in the last few months was some of our very best. In her early years, Pigcasso hit the canvas with such gay abandon that sometimes she'd swipe right off the edges, from one side to another. But as she got older and started gearing down, the strokes seemed a lot more deliberate and, dare I say it, intentional. As a result, we really were in flow: complete union.

We'd hit a purple patch, and although Pigcasso made it all look so easy, I can honestly say I never, ever took it for granted. Aside from the reality of knowing that her natural life span was relatively limited, even without some dread disease or condition, there was another equally serious

threat to our collaboration: what happens if she wakes up tomorrow and decides she doesn't wany to paint anymore? Of course, I hoped to keep going as long as possible, but the thought went through my mind almost every time I walked through the barn. Perhaps that's why, as was the case with Oscar, I'd looked into Pigcasso's human eyes every single day I was with her and thanked her, often out loud, for giving me direction and purpose, for our time together and the extraordinary results of our partnership. Pigcasso had taught me the real meaning of gratitude, and I'd be forever in her debt.

Those were the feelings flooding over me as pulled on my travel socks, plugged in my earphones and flipped through the in-flight magazine in search of the entertainment guide. I don't know exactly what triggered it, maybe a Sotheby's advert, or perhaps the choice between chicken or beef offered on the in-flight menu card, but all of a sudden an image flashed before my eyes: the half-finished work that I'd left behind in the barn, propped up on an easel in the middle of the floor. And a nagging thought rattled around in my mind all the way to the northern hemisphere. Was that the last piece we'd

ever paint? And if so, how would it stack up against some of history's great final artworks?

Whether it's on purpose or just coincidence, artists have a habit of going out on a cloud of irony. When they recorded *The End*, do you think the Beatles knew it would be the last time they'd ever record as the Fab Four? Could Andy Warhol really have known that *The Last Supper* would live up to its billing? If our moment had finally arrived, would we be going out with a bang or a whimper? It would be hard to come close, for example, to Claude Monet's *Grandes Décorations*. Paris's Musée de l'Orangerie stands on the Place de la Concorde just down the road from the Louvre. In a city that oozes art from every pore, you have to offer something really special to stand out, and l'Orangerie does it with Monsieur Monet's water lilies. Standing in two oval galleries, surrounded by the giant murals that wrap around both chambers, it feels like you're inside Monet's mind – or perhaps just the last ten years of it. Because that's how long he took to fill the pond. The reason I was thinking about it as I sat on the plane was that, as the years went on and his cataracts grew, Monet's health and eyesight failed fast, and by the time he gilded his last lily, he even had to label his

paint tubes. When you know that, the work suddenly takes on a different tone, literally. You realize the colours are slightly dull compared with the vibrancy of his earlier work. There's a lack of clarity, as if, even by his impressionistic standards, the camera lens needs a clean.

Pigcasso would definitely sympathize with Monet's physical decline, but she'd be even more moved by Henri Matisse, whose last decade at the easel was cut short thanks to a cancer-related operation that left him unable to walk. Fortunately, he could express himself in more than one medium and turned to paper-cuts and collages. The shift resulted in some of his most celebrated works, like *Blue Nudes* and what is thought to be his final collage, *Le Gerbe*. Pigcasso's career prospects were a lot more limited, even if we could find someone to design a squeal-chair.

Our unfinished painting in the barn studio was a lopsided affair: a few swipes of red on one side, waiting for more. Just like Keith Haring's *Unfinished Painting*. Haring was a proudly gay activist in the AIDS era, and his final collection of graffiti-like outlines was prematurely halted, like his life: protesting purple figures stuck in the top left corner of the canvas, forever. He was so young,

just 31. This was in the 1990s, so he knew his life would be cut short by a disease that was more of a stigma than a recognized health crisis. That thought alone gave me a lump in the throat. I knew from the start that even for healthy pigs, a human year is four pig years. A pig that makes it to 20 is an octogenarian. Realistically, how long would we have: eight years, maybe ten?

Then, of course, there was Picasso himself. By all accounts, his last five years on earth were his most prolific. Perhaps sensing the inevitable, he swished away in the kind of frenzy that you'd expect from, well, Pigcasso! His palette became increasingly simple, the compositions increasingly infantile; the overall effect, increasingly brilliant. And what I always remember is that he apparently ended up painting directly from buckets of paint, armed with a wide brush. Sound familiar? Although there's debate about what his actual last work was (he literally kept working until a few hours before his death), it's his final self-portrait, titled *Facing Death*, that sticks in the mind. Morbid crayon tones reveal a skull-like visage with huge eyes. It's not a portrait, it's a death-mask, staring straight at you as if it's searching your soul for answers. He died at 91 (that's 23 in pig years).

As I put my phone into flight mode, I noticed a final message from Neil. There were a few more tests he wanted to do that might give us a better idea of what the underlying causes were, and hopefully what, if anything, could be done. But the lab results would take a few days at least and there was nothing to be done other than buckle up and enjoy the flight. Easy for the captain to say . . .

19.
Letting Go

If you ever want to shock your system into gear and get a new perspective on life, try plunging into Icelandic streams. Or doing yoga in a swimsuit, in the snow. It was extreme both mentally and physically, but truth was, I'd arrived at the retreat with a shaken core. The cold and ice found the cracks and exposed my vulnerability even more. I found all the deep breathing and reconnecting with my inner self extremely emotional and quickly realized that I'd

been disconnected from plenty of things, myself included, for rather a long time.

Running, doing, moving, painting: *carpe diem* at the speed of light, watching everyone around me run for cover as I sped by. But if everything was on track, the plan was working and we'd proved pretty much everything we'd wanted to, then what on earth was I still chasing? What was I trying to prove? To whom, for what? And just like that, in the freezing cold, I felt my brain began to thaw. I'd been so focussed on creating an environment for Pigcasso to make people question their perspective that I'd completely lost my own. It was all very simple.

I'd often thought that one day I might chuck it all in and withdraw completely into the woods. But that wasn't what was going on. What I needed was to have a good look at my life map for the immediate future and choose a destination. And then work out how to get there without relying on major highways, and being extra careful to stay clear of the autobahns with no speed limit! It was time to take the scenic route and enjoy the journey as much as the end result. Slow down, be in the moment. Basically, do everything the self-help books suggest. The idea itself was

hardly new, but what I realized in that moment was that having thoughts and acting on them are two very different things. And I needed more of the latter to take control of life, rather than having life taking control of me. For that week in Iceland, with my phone and computer mostly in hibernation except for evening check-ins with Pigcasso, I switched digital for physical. I read my first book in decades, *The Surrender Experiment*. Its message? Stop chasing what you think you want, enjoy what life offers and what you have to offer others. In the echo-chamber of isolation, I had time to step back and question what made me tick. More importantly, I asked myself how I wanted to show up in the world. You can't be a lover and a fighter simultaneously, so which one was it going to be?

I wasn't becoming a Nordic hippie, but confronting Pigcasso's mortality put my own into sharp focus. It wasn't something I'd thought about very much. There was always too much to do to spend any time worrying about what it would be like when there was nothing to do. If I was brave enough to ask the hard questions now, perhaps I'd be happier later. I couldn't help thinking about my aging father: 86 and so very fragile. Still mentally sharp, but

somehow unable to find any balance, he'd be viciously angry one moment and deeply emotional the next. He was hurting inside and impossible to deal with. But was that a good enough reason for me not to spend more time with him? Did he have regrets? And would I regret not being witness to the final act of his long-lived life?

Sometimes I think that if I ever had a coat of arms, it would just be a massive question mark on a blank white shield. But in that moment, the questions were coated with a sense of urgency rather than anxiety. I could physically feel something had shifted, as if I'd been looking at the world through a pair of binoculars without realizing they were out of focus.

My team at the sanctuary had been sending regular updates on Pigcasso, so by the time I finally packed my bags and started the long journey home, I knew where things stood. She wasn't getting better, but wasn't getting worse. She seemed to be stable in her unstable state. I was relieved. I wanted to have more time with her, and certainly wasn't ready to say good-bye from 11,000km away. And I had a small gift I was dying to share with her. With a few hours to kill in Frankfurt Airport, I had stumbled into

a specialized spa and wellness shop in Terminal 1 with an assortment of hand-held massage machines. German precision at Duty Free, how could I resist? 'We do have smaller ones over there,' said the shop assistant. 'Thanks,' I answered, 'but it's for my pig.' She smiled and I could read her mind: 'Poor girl. Must have had a long connecting flight. She's lost her marbles.'

Falling peacefully asleep on that flight was never going to happen. As soon as I put the mask on, all I could see was an image of John, smiling and gracious, welcoming me home. He was a simple soul: kind and hardworking, and eternally grateful to Pigcasso for the life she'd help him create. John and all the team members were given a commission for every painting sold. It was my (our) way to say thank you for their caring spirit, their patience, their compassion. John had managed to school his daughter in Malawi. Evelyn got her driver's licence and bought a car – a very used one with a few miles on the clock, but to her it was a limousine. Clint had moved from a tin house on sand to one built of concrete and stone. Even the shelter dogs through the adoption centre were beneficiaries of Pigcasso's success. Oscars Arc had homed well over

4,000 shelter dogs by this stage, and she'd funded food for them over the years too. Indeed, they were rightfully proud, one and all, of making something of their lives. And all because of this pig.

I could picture the peanut gallery watching me walk through the barn: Baloo, Moo-tise, the sheep, the goats and that glorious peacock. He had arrived as an ugly duckling barely bigger than a sleeve of golf balls and turned into the ultimate show-off, strutting around as if the whole place was his personal catwalk. I couldn't believe that Baloo was the same tiny creature I'd found in a back yard, helpless and hopeless with a rusted chain jangling around his neck. Look at him now, towering over the stall gate, looking for something to lick.

Then I was back in 2013: a naïve gal walking across a bare and barren field, dodging molehills and picking the occasional 'devil' thorn from my foot. I remember sitting cross-legged in the middle of the site and sketching ideas as ants walked across the pages of my notebook. Line by line, the doodles became plans, and plank by plank, the plans became a barn. The sound of hammers and bulldozers echoed across the valley as the arc rose from the ground.

I remembered the spiral iron staircase finally being positioned and the first time I stood in the loft looking down at my little kingdom. I'd place my MP3 player beside me and blast Andrea Bocelli through the roof – after the builders had departed, of course. That loft became my crow's nest, then an office and finally a guest bedroom that would be fully booked every day of the year. I'll never forget the smell of newly sanded beams, coated in varnish. Then the windows went in. What a mission! Nothing was hanging on the walls. The barn was empty and clinical. There were still brushes, nails and paint lying all over the deck when the animals began to arrive. Pigcasso, the first, hoof in hoof with Rosie. Slowly but surely, the gentle sounds of animals began to fill up the high ceiling space, while scraps of art paper with unfinished strokes fluttered across the floor.

I caught my reflection in the glass doors in front of the barn and suddenly I'm ten years older. From weeds to wonder, how far this place has come. As those scraps of paper started to sell, the barn got more bells and whistles, the signage improved, the décor upgraded with all the right messaging. A growing family of animals, from the featherless

chickens to the shaggy sheep, got more hay and more feed and better care. We built a couple more guest rooms, to draw more people, to spread the word farther and wider with every passing day. The last thing I remember thinking before finally getting an hour or two's sleep was how privileged I've been to be able to act on my calling. The fields are fertile, the flora and fauna are fabulous, the vineyards are abundant and the fences are well and truly mended.

When the aeroplane's wheels touched down in Cape Town, I took a deep breath. Then another. And then another. Breathing consciously was a new trick I'd learned in Iceland. It's more than a technique, it's a way of bathing yourself in lightness. Honestly, it feels as if you've discovered a secret key to a lost door somewhere deep inside. And behind that door you'll find a new friend, or perhaps an old one you haven't seen for years. I couldn't wait to introduce her to all the animals, to the farm and, especially, my pig. In slow motion. Appreciating every second. As it turned out, the universe laid out a red carpet: a straight run through Cape Town International. I was first to walk off the plane, first through immigration, and with no baggage to collect off the carousel, out of the

terminal and in the back seat of an Uber within 30 minutes of landing. Inside an hour, I'd be looking at Pigcasso, eye to eye.

My heart was in my throat as I walked up to the barn: prepared for the worst, and totally accepting of the fact that my artistic collaboration with Pigcasso might be over. She had been my creative confidante for over six years. Now she would nourish my soul, and I hers, through reflection and gratitude. I wiped the tears from my eyes, pulled down my sunglasses and walked into the barn. Pigcasso was standing up with John at her side. He was rubbing her back legs in long, gentle strokes. She didn't so much as wink in my direction. John had obviously missed Pigcasso, but from the soft grunting and the way she was craning her neck, what was more noticeable was just how much Pigcasso had missed John! She was in far higher spirits than when I had left. I asked how she was doing. 'Good-good.' Simple yet sincere. Clint stepped into the conversation, suggesting she'd been 'almost back to normal' ever since John had returned. 'He is now officially Pigcasso's husband,' he said. We all erupted in laughs. John didn't flinch. He was extremely proud of his animal

husbandry skills, and Pigcasso seemed equally proud to have him as her lawful unwedded human.

Jokes aside, she really was in a much better state than I expected. Had Pigcasso's condition somehow been related to a broken heart, I wondered? We all knew pigs have deep feelings for, and develop strong bonds with, each other. Maybe they do with Malawians too! I was rational enough to know that the vet's diagnosis was sound: a neurological condition can't be brought on by a broken heart. But who knows the healing power of a mended heart? Whatever was going on, it was curious in the extreme, and there was only one way to find out for sure how she was feeling.

We all woke up early the following morning, washed the brushes, shook the tins and set up the studio for a painting session. And as I dipped the brush and set it on the edge of the tin, everything felt a little bit different from ever before. It's always been Pigcasso's choice to paint or not on any given day, and as I've already said, I am mildly nervous every time we work together. Pig-related performance anxiety. But this time, there was none of that at all. There was absolutely no expectation. The bikini on ice treatment had chilled me out in the best possible way.

John had already got Pigcasso up and was testing out the high-tech massager on her hind legs when I signalled to him to point her towards the canvas. She headed straight towards it, still stiff on her hind legs, but not even the slightest bit wobbly. Sluggish, yes, but stable. And as if nothing at all had happened, Pigcasso proceeded to paint. Slow strokes, wide creative angles. She was gentle. I was patient. And the entire morning session was a dance of acceptance and awakening: of letting go and loving the moment. I got totally lost in the process, so engrossed I didn't even bother to look for patterns or rotate the canvas. It was all about Pigcasso expressing herself fully, filling the canvas with a whirlpool of colour: a glorious, unregulated, intentional mess. We were different, but we were back.

The weeks that followed brought on lazy summer days at the sanctuary and a new obsession with podcasts and books that challenged everything I 'knew'. I'd always hoped Pigcasso would make others question their beliefs and now, thanks to her, I was doing exactly the same thing. The thought of her dying had turned the polarizing filter on my entire world, adding a definition and intensity that I'd not noticed before. I saw sunrays glistening through

the dusty windows and nestling on the straws of hay that settled on the barn floors. I watched tiny spiders spinning webs, and marvelled at the way the geckos magically clung on to a world turned upside down. I didn't hear birds singing, I listened to birdsong.

I had also developed a heightened awareness that Pigcasso's fragile existence was inescapably linked to my own, as far as any artistic aspiration was concerned. My time, my 'career', my daily existence – I had always been a helpless follower of her state of mind, but how helpless would I be if she wasn't there; what value would my signature have without her snout-print alongside? I remember the day I lost Oscar and how life as I knew it had shattered the foundations of my existence and beyond. I knew better now, and I felt compelled to prepare for what was now an inevitable fate. And for the first time I began to think outside the box, to visualize an independent future beyond my wonderful pig with whom I'd walked the most unusual and incredible journey. A new project with another animal, perhaps? What dreams and possibilities still lay ahead, and what creative boundaries could I push if I started to manoeuvre in that direction? Could

I leverage off all the lessons this pig had taught me? It was an interesting thought. No, wait: make that exciting. A new challenge, new cause . . . oh my, are those butterflies I feel fluttering somewhere deep inside?

I also realized I hadn't allowed myself to enjoy the barn loft for many years. It might have ended up as our most popular guest room, but it had started out as my personal dream. So I spent days at a time up there with my loyal dog Frankie (whom I'd adopted in January 2020) at my side, enjoying the sounds of silence punctuated by singing crickets, the occasional hoof clunking against wood or Baloo's breathing, which on occasion sounded like a massive pair of bellows. Every now and again the goats nestled in and irritated a pig. Make that Pigcasso. I can't claim to actually speak pig, but in the darkest night, I'd be able to pick her out. Every pig has their own way, and I know hers so well.

I was enjoying the space so much I felt inspired to make it even better, and had a deck built alongside the bedroom. At first I had an old wine barrel put in place to serve as an ice bath, but quickly realized that if I put a regular tub out there, one side would face the mountains and the other,

the setting sun. On a clear night, you can bathe under a blanket of stars, get lost in the milky way, gasp at shooting stars and ask yourself the same question that human beings have asked for thousands of years looking up at the constellations: what's it's all about, anyway?

There's a lot we still don't know, but we do know that this final chapter isn't Pigcasso's. Her last work of art is still not painted, and we have no idea how many more there will be before she goes to the great velvet-lined sty in the sky with an endless supply of truffles and avocados. As for me, I'm still looking for answers to that question written in the stars (aren't we all?). But I'm a lot closer now than ever before. And like any good hero on a journey from awakening to enlightenment, I wouldn't have gotten there without a mentor: a worldly wise figure with mystical powers to prepare me for the journey and the battle to come. Bilbo Baggins finds Gandalf, Harry Potter needs Dumbledore and without Mr Miyagi the Karate Kid would just be another kid. And me? Well, that's easy. I just had a pig. A pig called Pigcasso.

The beginning . . .

Acknowledgements

Before I go, I need to give a massive shout out to the people who have made this story – and publication – possible. The fact is that if it wasn't for a rare breed of individuals that I have been graced to meet along this country road, you and I wouldn't have met, Pigcasso's body parts would have long since been devoured and digested without a gram of gratitude or consideration and, well, the person next to you wouldn't be thinking, *'Million Dollar Pig*, huh?' So I leave you with deep and heartfelt thanks . . .

To my editor. Actually, he's more than that. I have to give him credit for co-authoring some key chapters in this book and for fine-tuning the rest. I first met Brandon de Kock in the late 1990s on a golf course in South Africa, where his mulligan nearly decapitated me and drilled a hole through

my golf bag. Surviving the curvature of his malfunctioning ball brought us together and, long story short, a decade later he ended up inviting me to write a column about women's golf for a national golf publication of which he was editor in chief. Over the years, I came to know this larger-than-life, charismatic, powerfully positive character. Then, just like his golf swing, we lost contact. Years flew by. Brandon kept writing and taking photographs and speaking in public. He even became an award-winning cookbook author (together with his wife) among other interesting endeavours (quitting the links included), while I rescued a pig who started to paint. A manuscript was written. If it had been a house for sale, it might have been described as a 'charming fixer-upper with loads of potential' in need of some love and care, or at very least, an editor of creative proportions. I scratched my head and then, eureka! I tracked down the only storytelling genius who I knew would be able to digest, edit and regurgitate my rough rhetoric. A bear hug and a coffee catch-up later, I laid Pigcasso's prose on the table, dodging Brandon's bacon and eggs. Sunny side up, he agreed, but it took some negotiating. Becoming a vegan wasn't a prerequisite for the job, check, and while he hadn't

heard of Pigcasso, I could see his mind was ticking. He realized the title of the book was closer to reality than he thought: I dangled the carrot of an original Pigcasso as an incentive, hoping it would seal the deal. And it did. The rest is history. This book simply would not have made it from farm to fruition without Brandon agreeing to caddie for me. Full stop.

A special mention here to Renata Harper, who Brandon brought to the table to give a third eye and an objective perspective when we were firing philosophies between each other.

To Trevor and the team at Octopus Books for believing in a pig, and my pen – and enabling us to share and expand our story and philosophy with the world.

To Alex Segal of InterTalent and Richard Nyman, who used their connections to find Trevor and to seal the publishing deal, thank you so much.

To my genetic material, Mum and Dad, *aka* Brian and Erica – where would I be without a bit of protein and a free-ranging egg?

To my junior-school teacher, Di Black, who encouraged me to think, and to live, outside the box. If she wasn't such

a legend, I would likely have dropped out of school and sunk my ambitions on the *Rainbow Warrior* in 1985, trying to save a whale!

To my friend Evelyn Hunter, who gave me my first lesson in carnism when, during a casual high-school lunch break, she questioned my eating a ham sandwich when I spent every other living moment trying to rescue and save shelter dogs. 'Not much of a difference, Jo?' Her point changed my menu, forever.

To Harald Seick for his constant support, and for graciously funding my dream of a farm sanctuary in Franschhoek when my life depended on it. And for quitting the foie gras and bratwurst on demand!

To Peter Singer, John Denver, Jane Goodall, Dian Fossey, Brigitte Bardot, Babe, Piglet and all their fellow philosophers, writers, environmentalists, concerned citizens and genuine animal-lovers engaged in building a better, kinder, more sustainable world through their words and actions. True respect.

To Renoir, the Royal Academy, Art Basel and all the sceptics in between, thanks for inspiring us to challenge the establishment. Sorry, but yes, this pig can paint. Get over it.

To the art connoisseurs and fans who have invested in a Pigcasso for all their right reasons: thank you, thank you, thank you. Your support and appreciation of her art has enabled this pig to fly and set her in the history books forever. But you've also supported the rescue and rehabilitation of hundreds of farmed animals and given them a voice in a deafening world. You've sustained the employment of a small team of caregivers, A special mention to the two big guns here: Patrick and Peter. Patrick, you would probably have bought the entire collection already, if only you had more wall space on which to hang them. Thanks, too, for keeping Pigcasso entertained with regular emails sharing insights of framing, gallery lighting, animal agriculture, intelligence and philosophy. And Peter, what can I say: you have supported the project since inception and your enthusiastic purchase of *Wild & Free* establishes Pigcasso as the greatest non-human artist in history.

To Oscar, my adopted dog who changed the course of my life and work, forever. Stumbling upon Oscar in a Cape Town shelter was arguably the greatest day of my life: losing him, the worst. But the lessons learned through life and death remain steadfast and true and constant, and

underpin all the good things that continue to happen, and for which there is so much gratitude. His legacy is simple: the adoption of thousands of dogs through Oscars Arc, as well as the creation of Farm Sanctuary SA and the subsequent rescue of Pigcasso. None of this would have happened without his presence, friendship and inspiration in my life.

And finally, to Pigcasso. My plant-based, creative, egoless superstar who is happy to stick it out in the mud all day without chasing fame, fortune and a Netflix series. If humans were more like her, the world would certainly be a better, kinder place. Pigcasso has gone above and beyond the call of duty to raise awareness for the plight of her fellow creatures and help repair the bridge between humans, food and our natural world, which has been broken for far too long. You, Pigcasso, are a stroke of real genius in a world of mediocrity, and your life and message are priceless; far more valuable than any painting ever sold in the history of pig-kind.

Index